You Can Draw Already

in this remarkable book, Artist Daniel McGowan
will show and prove, that everyone can draw already!
If you think you cannot draw, think again.
The ideas in this book are sound, original, easy to
understand and the results will blow your mind!

Daniel will prove to you, how simple it really can be.

Using letters and numerals, plus other well known
shapes, you can draw and create anything from
Funny Faces - Animals - Trees - Flowers - Landscapes -
Seascapes - Figures - Portraits - Buildings - etc .
They are all inside waiting for your pencil and remember,
every subject is made up from letters, shapes and
numerals which **You Can Draw Already!**

I had so many requests to write this book, mainly because of its simplicity and effectiveness, not only with children, but adults too. I have given demonstrations at various Fetes, Shows, and exhibitions and people have been amazed (including myself) at how, in a few minutes, they were all able to draw Funny Faces even though they had said "I cannot Draw at all"
The phrase I kept hearing from everyone was,

"You aught to write a book , this idea is fantastic"

Well, here is the book. It has taken me ages to put it together, but it is finally here. I am also in the middle of writing another two books, '**The Clock System** ' and **'Drawing With Triangulation'** which is more advanced and may I suggest, this as your next step to progress further into detailed drawing, but more of that later.

Please recheck and look at the title of this book. It does not say How anyone can **Learn** to draw, because you **ALREADY CAN** and I am going to **PROVE** it to you.

YOU USE AND CAN DRAW LETTERS & NUMERALS.
What I am going to show you, is how to transpose these into Faces, Eyes, Noses, Animals, Trees, Flowers, Landscapes, Buildings, plus hundreds of other objects of your own choosing.
You will begin to see everything in a new light and once you get the hang of it, you will be amazed at what you can achieve in a short space of time. What's more, I Personally Guarantee by the time you finish this little book, your life, yes, your **life,** will take a fresh look at your surrounding world. In short, you will become an Artist!

Okay sounds too good to be true, but I promise you it is not. Anyone who has attended my demonstrations, knows that in less than five minutes, (I'll repeat that), In less than five minutes, I will have children and adults drawing funny faces, cartoons, animals etc. Yes, no matter what your age or situation **you can draw already**. All I have to do is set your imagination and visualisation whirring and Bingo! You are an artist.

Well that's great!
Does this mean I can I now take my work to the National Gallery or sell it for 1,ooo's of Dollars, Pounds, or Euros on line?

Er well, yes,. you could and there are many so called artists doing just that, but I prefer it if you hold your horses and PRACTICE and I do mean PRACTICE and lots of it.

This as a simple

Three Step Project 1 - 2 - 3

Step One (1,1,1,1,1,1,1,1,1,1,1,1)

You already know your letters and numerals so throw in dots, dashes,, comma's full stops, question marks, pound/dollar/euro signs, circles, squares, triangles etc for good Measure.
That is Step One and you already know how to draw these.

Step Two (2,2,2,2,2,2,2,2,)

A lot of fun and very easy to do. It is **look**, yes, **look** for these letters, numerals and shapes and I promise, you will find them **EVERYWHERE**. Remember "Seek and ye shall find"?.
Or pray to Saint Anthony. Do whatever it takes, but do it.

All the signs and shapes are there if you look carefully enough.

Step Three (3,3,3,3,3,3,3,3,3)

Third and final step is easy too, but the hardest step for most people to follow and that is do not just read this book, but **Do** and **PRACTICE,** yes, **PRACTICE**.

Practice looking, seeing and drawing letters, numerals and shapes and remember ,
you can already draw every one of these now!

The more you do this the better you will become. Like a piano player practising his scales or a Marathon runner doing extra miles in training, like the good book says
 "Ye will reap what ye sow" Or something like that, or "You only get out what you put in" which most people do not do, but hey, you are different, you have bought this book and have a wonderful head start, so now let the Fun begin:-

Test you Imagination

Here is the capital letter 'A'. But can you see it as something else? Perhaps if I made it larger on the page like this?

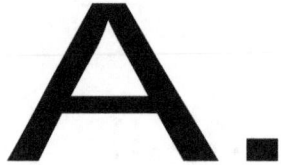

Okay. I know I'm daft, but I can see a decorators step ladder with a pot of paint beside it

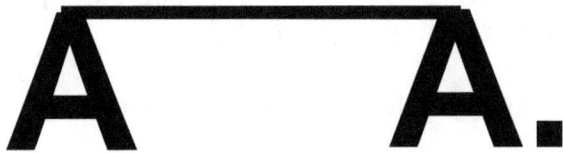

Does this make it any easier? I now have two step ladders and put a plank across the top.
(I think the painters may be out to lunch).

As you can see from the above example, using your imagination, it is quite easy to picture and draw something you already know and can do. My job here, is to show you how to see, alter and refine these letters, numerals and shapes into proper drawings and it is going to be much easier than you think.

We will pick some easy Funny Faces to start with
Draw a large zero or Egg shape like the one below

Hey! Look! You can Already Draw an Egg

Now about half way down put two dots for the eyes. (Full Stops).

Just above draw two 'C's on their side or 'V's upside down to make eyebrows

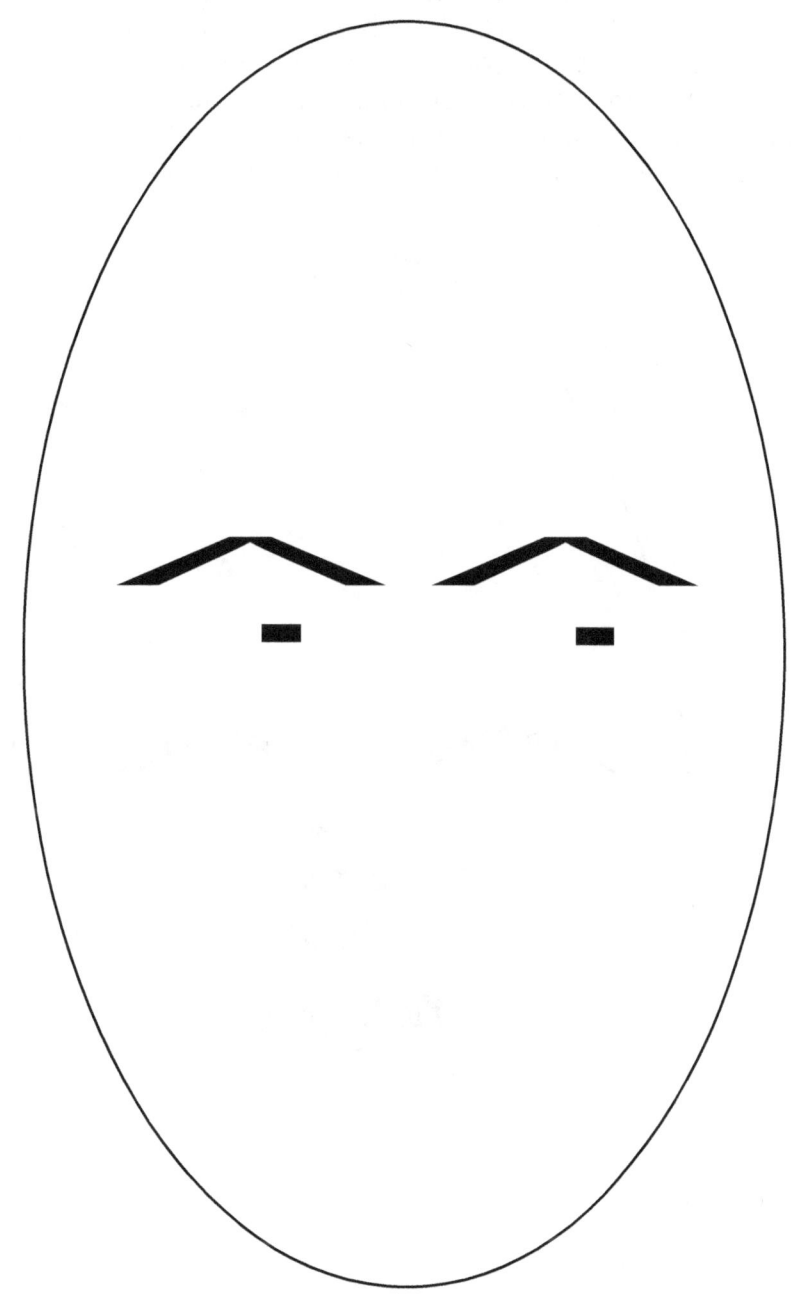

Now you can make an 'A' for the nose and add a smaller 'V' underneath for the nostrils.
An 'M' for the mouth could be fun too and Voila!

Congratulations, you have just drawn your first
Funny Face a bit primitive perhaps, but you can see it is a face and you have proven to yourself
That you can do it

Now add a bit of refinement to these letters and you will really start to see the potential of what you can do. For instance, removing the bridge on the 'A' would make it appear more like a nose. Stretching the 'M' for the mouth wider, would again make it more like a mouth and you could add a wider 'U' for a bottom lip. I am sure you can think of a few more things to improve it. On the next page. I have examples to copy, but remember, even at this early stage, It is important for you to start to making up your own Funny Faces, using letters, numerals and shapes.

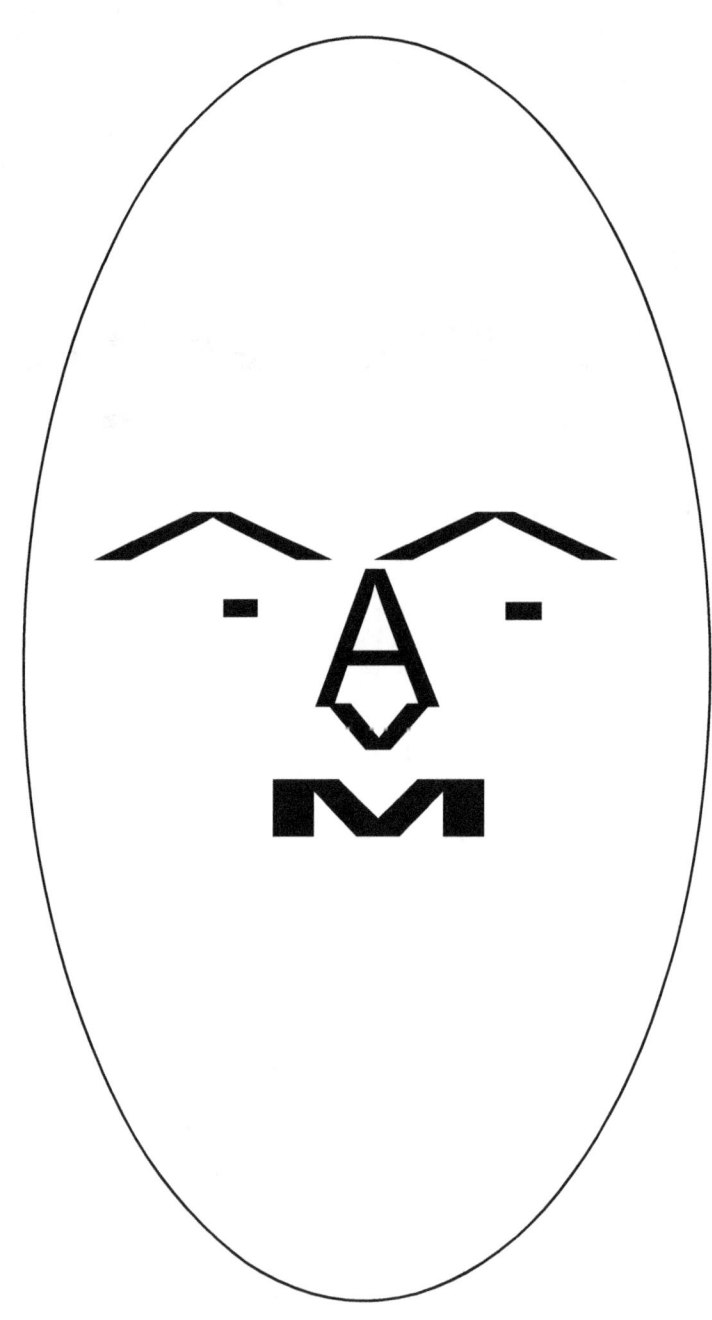

On this page I will show you how to create a few different eyes, noses, ears, mouths and expressions, together with examples. Because I am on the computer, these are very rough with me copying and pasting the letters and numerals. Later on I will show you proper drawing examples and how you can refine your work.

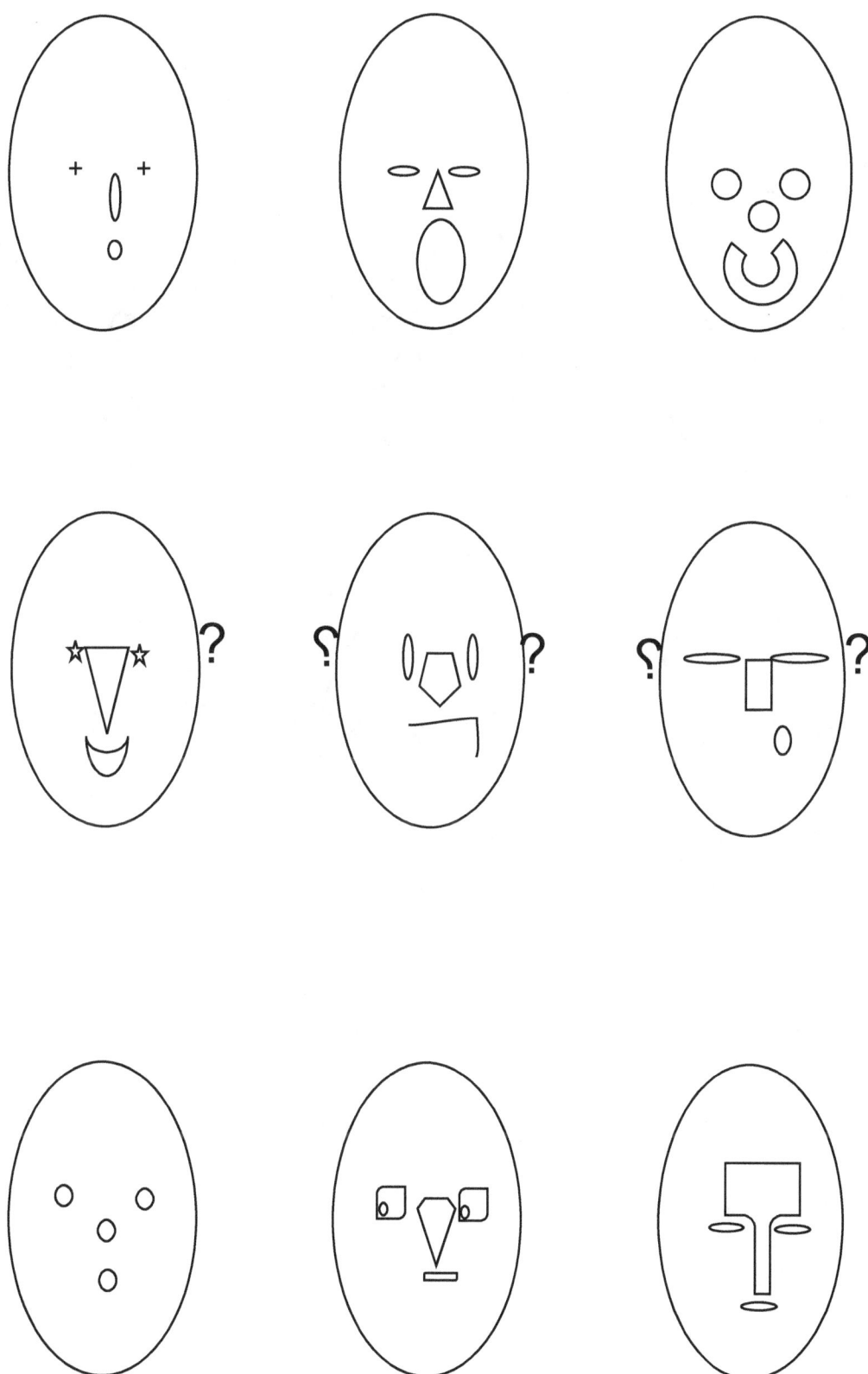

Here I have drawn nine examples for you to copy. They are all made from letters, numerals,, Shapes and signs you know. I have drawn these with a black marker pen.

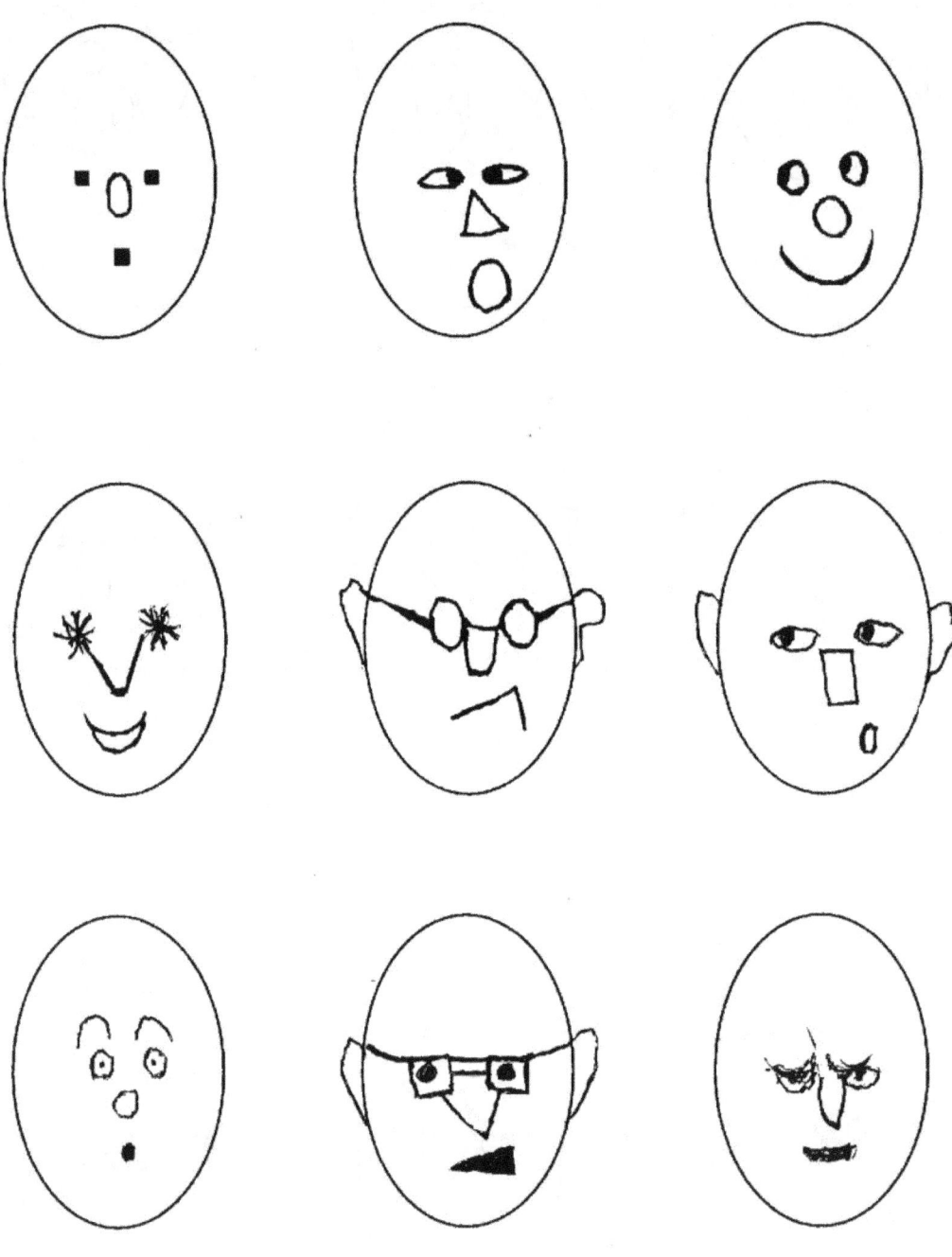

Over to you……………………Practice page
Make a copy of this page and draw all the eyes noses, mouths and ears using letters and numerals. You could even add some hair.

When drawing faces, funny or anything, I recommend you start with the outside shape, i.e. the head. You may see some artists who begin with an eye and good luck to them. This is **not** the traditional method and can make it hard work. With experience, you will find, whatever you draw, a lot easier if you work from the outside in and **not** the inside out. Imagine trying to Draw a bicycle wheel this way! Which would be easier and quicker? Think of your drawing as a jig saw puzzle, start with the outside border first, then look for what will fit inside. All shapes are important to the artist, especially faces. Not all Heads and faces are oval, in fact, none of them are. Here are a few cartoon head shapes to draw. **All these shapes are fundamentally important for drawing**, so practice them over and over. A great artist once said "If you can draw a square, a circle and a cone, you can draw anything" (and he could), however, it Is my belief, the average mortal needs more, so I have provided you with six basic shapes. When you have drawn these, add the eyes, nose, mouth, ears and maybe hair too!

Okay. below you will see the same cartoon head shapes to make Funny Faces, but this time I would like you yo draw them in profile!. I have given examples, so draw these on a separate sheet of paper, then try a few of your own. Use normal 'V's, 'U's, 'C's, Question marks etc. Then alter and refine them, for a better effect.

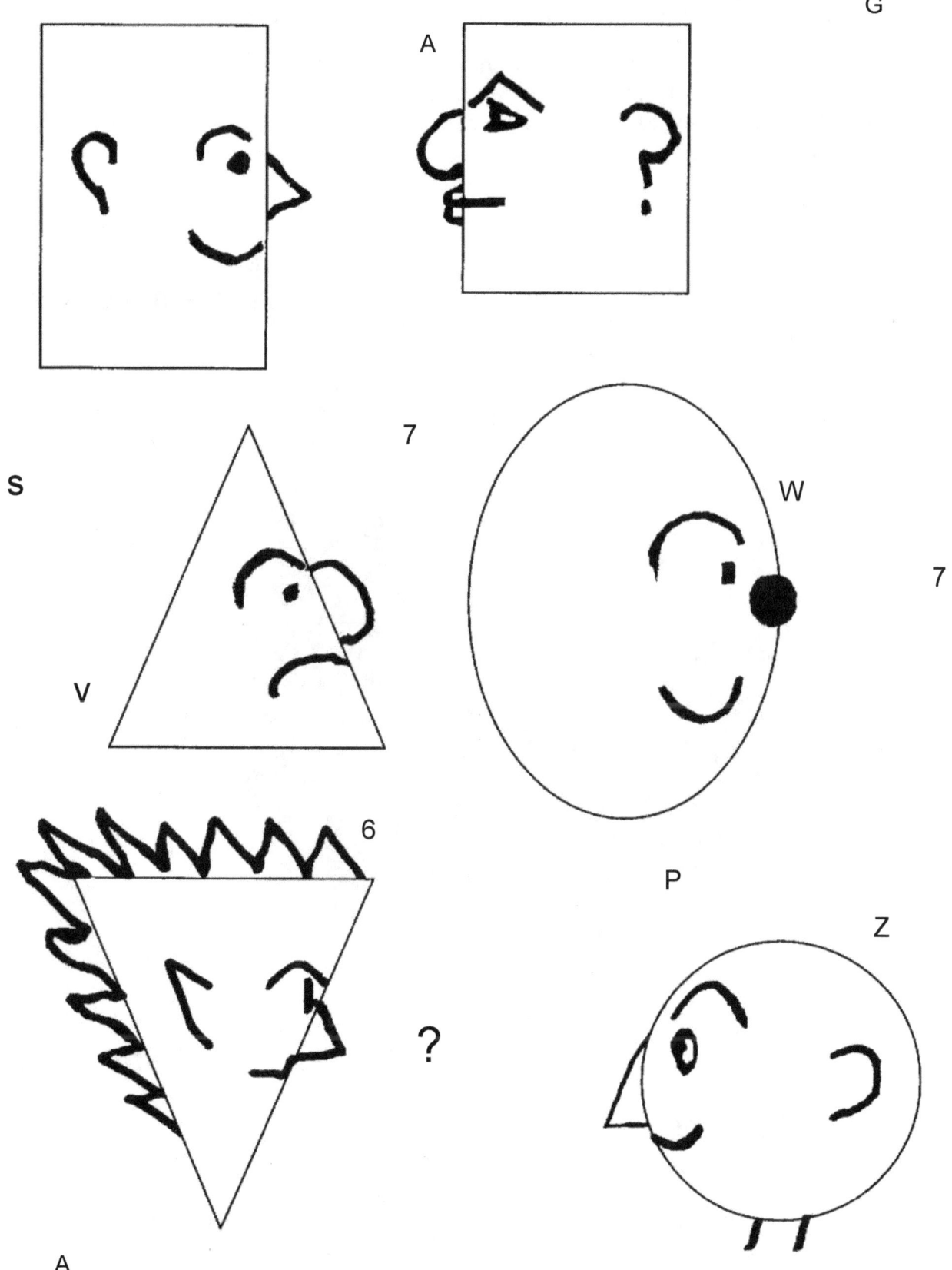

By now you should be getting on like a house on fire with your Funny Faces, but keep practicing and see what different features and faces you can make and do not forget expressions too, like Happy, Sad, Anger etc. The next little project I am going to give you is **ANIMALS**
.
Here is a Chicken for you to copy, then using the same animal, draw different shapes of your own. (Do not forget the eggs. What on earth could you make those out of?).

In case you are stuck as to how to start your chicken, the letters consist mainly of 'V's and 'U's. Can you see that? Anyway I have put them nearby to guide you.
Later on, when you learn how to refine these, you can draw the chicken again and note how much better he will look.

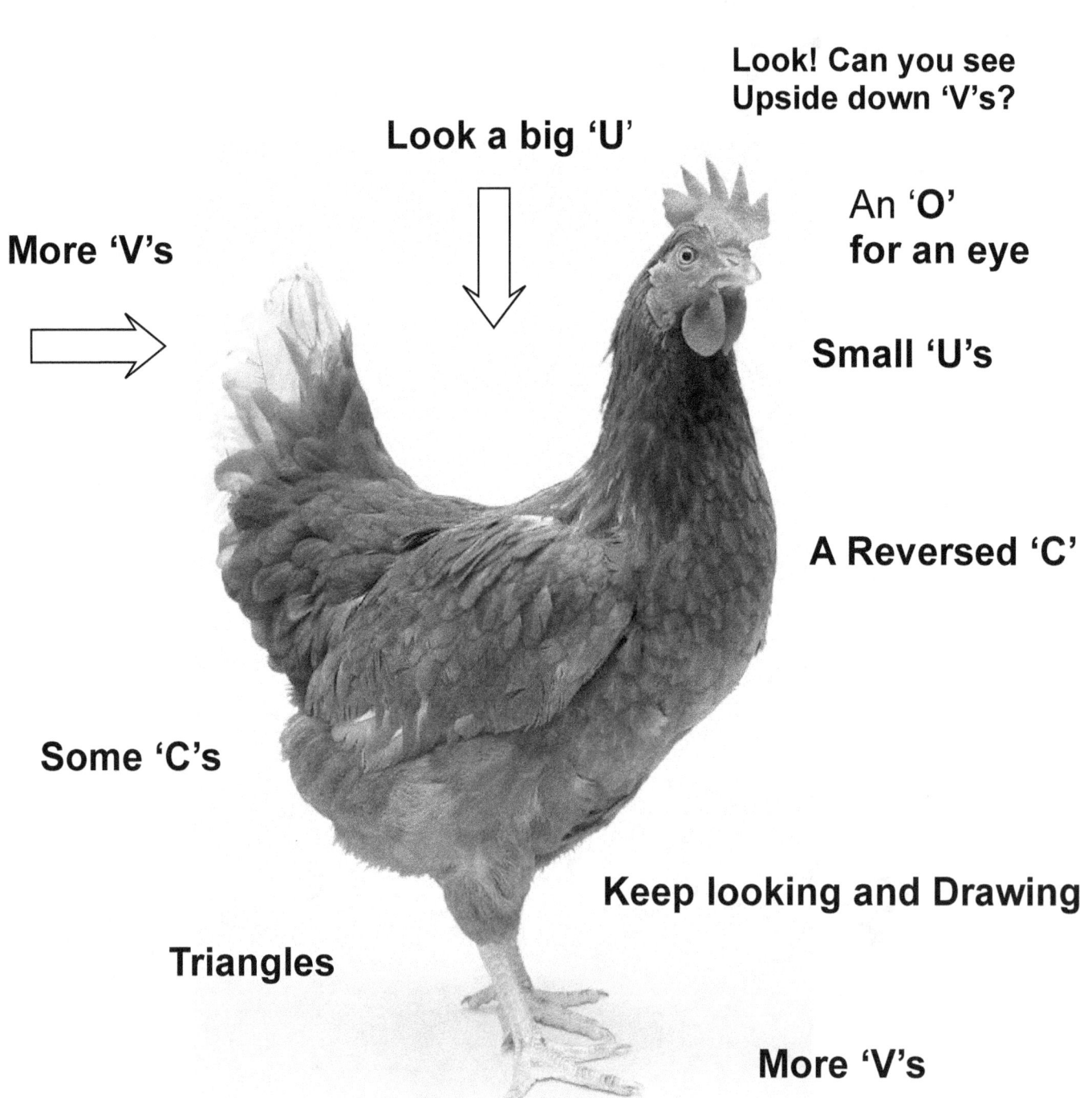

Here is my example of the Chicken using the letters given in the previous page.
Not perfect by any means, but you can see it is a chicken and with a little bit more care and
attention to the letters, numerals and shapes, you should end up with a good drawing of him.

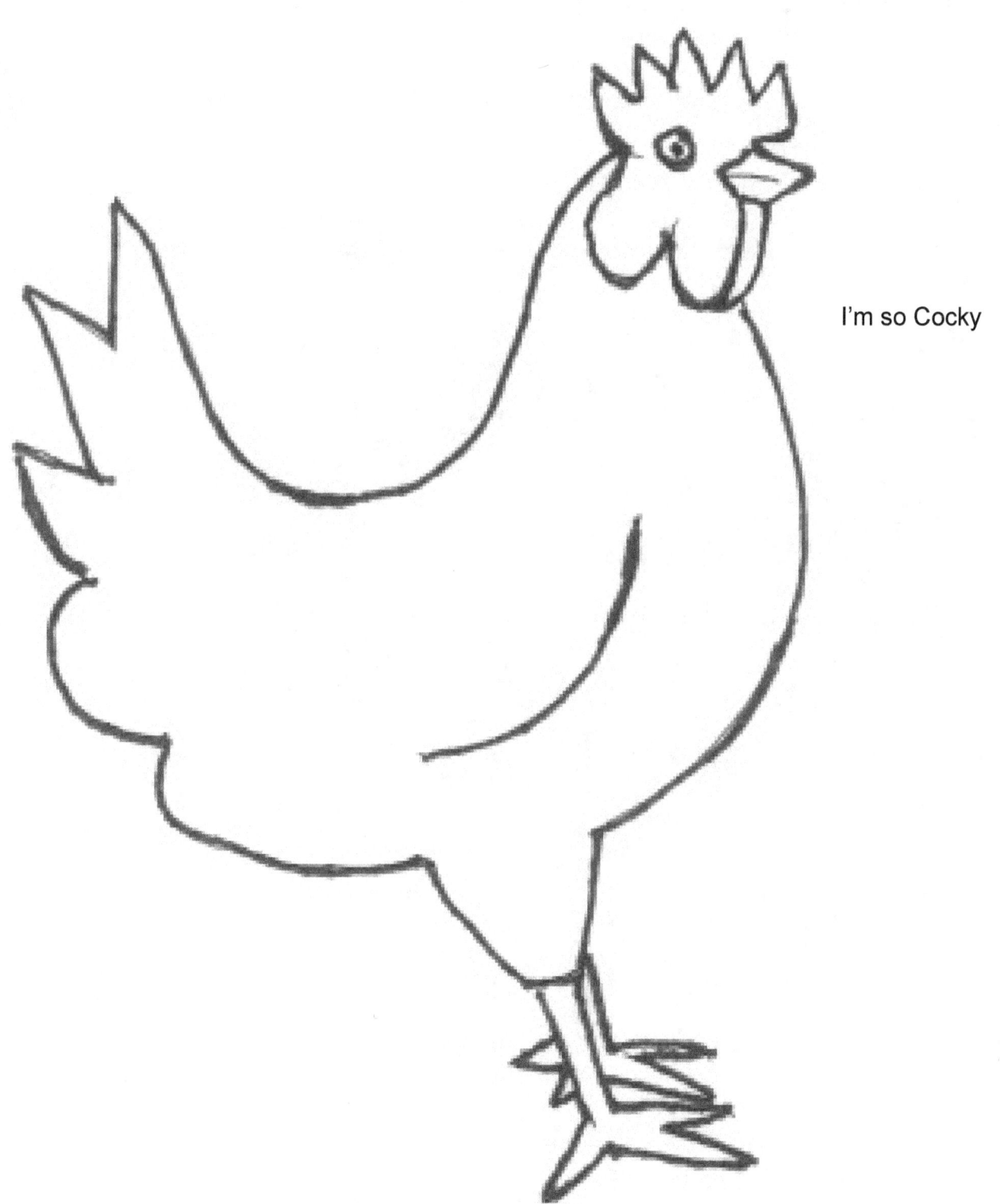

I'm so Cocky

How did you get on?
Well I hope. Do not forget you can email any questions. I an always happy to help all I can.

Still on Animals, how about a DUCK and a SWAN?
Here is an example for you to copy, but please try one of your own afterwards.
You can do it.

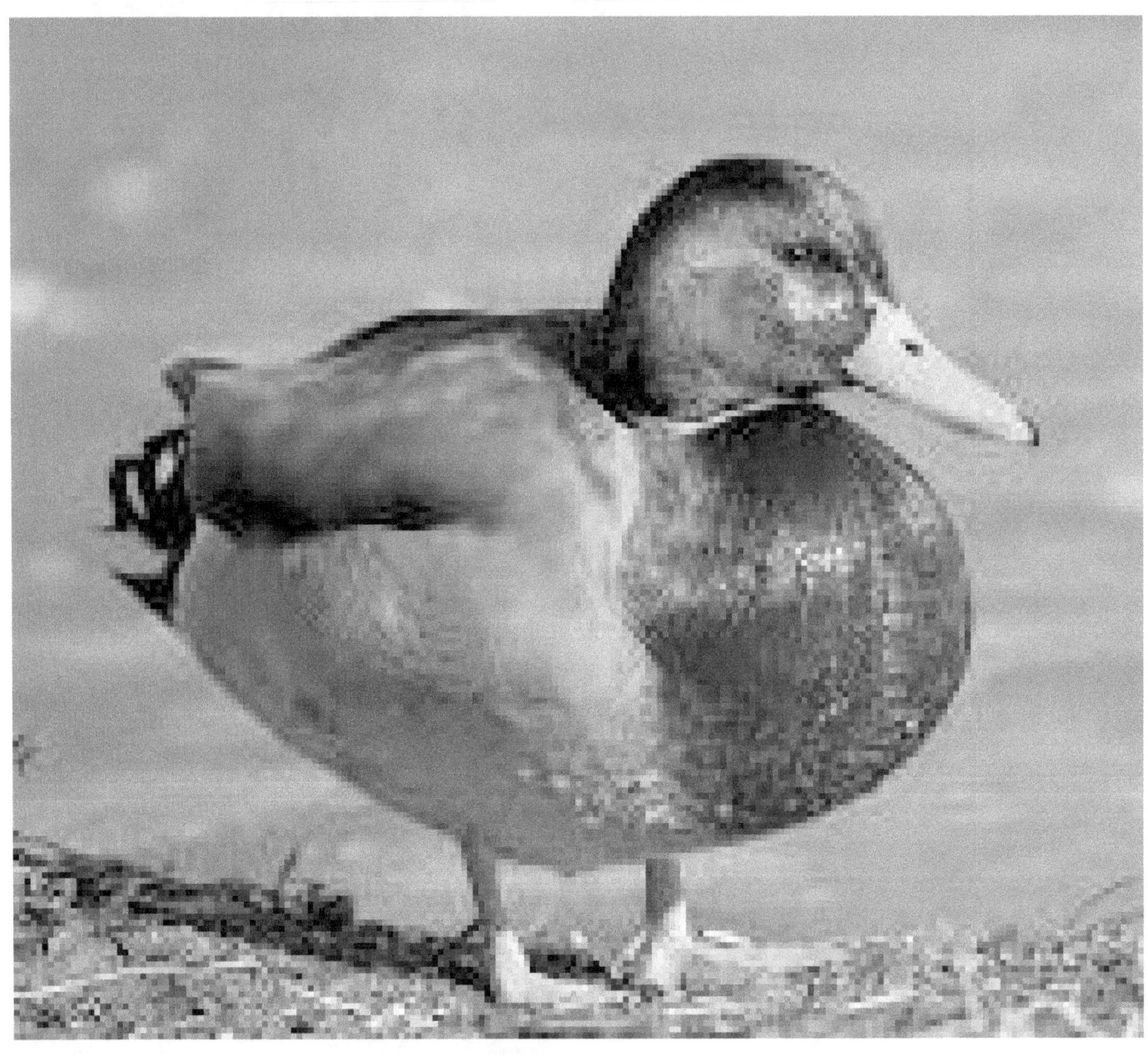

A lot of 'V's circles and '11' for his legs, notice too, he is squatting down and his whole body is an egg shape.

Here is my Duck. I have drawn him quickly with a ballpoint pen, given him a bit of light and shade, but you will notice, I have purposely kept to the shapes of 'V's, 'U's, 'C's and 'O's, yet with a little more refinement and alteration, he could be almost perfect7

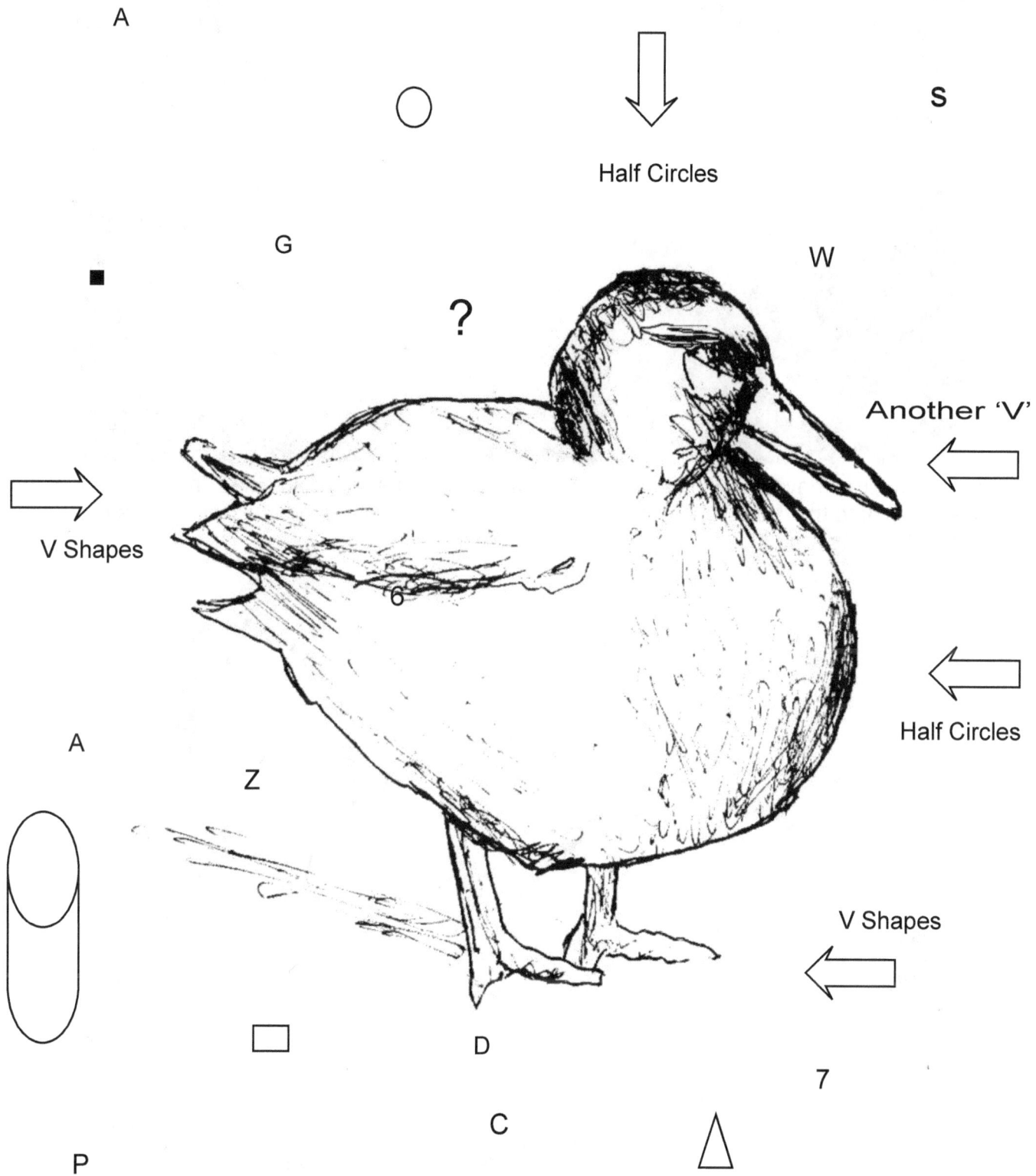

Here is a Swan and you can see his neck is the shape of a large 'S'
Big 'V' for his tail. Upside down 'U' for his top wing. 'V; for his beak and black face,
and an'O' for his eye. Oh my! This is just too easy.

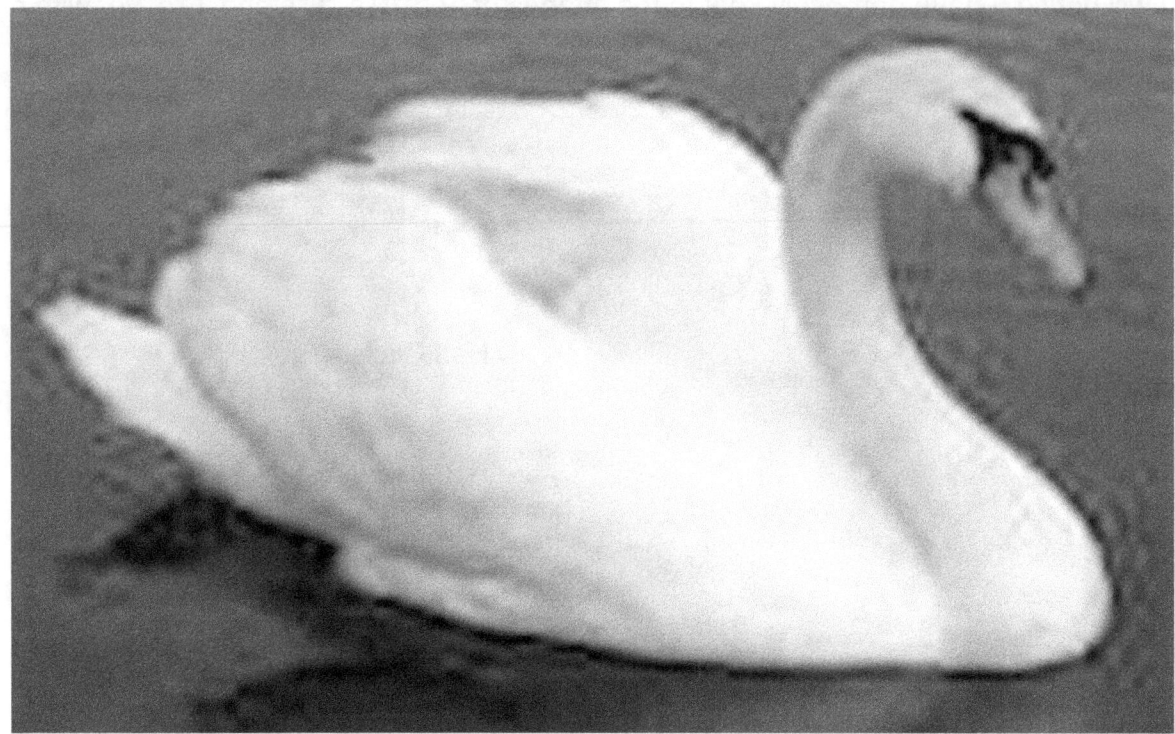

Here is my swan. I have drawn this with a few simple lines, using a thick black marker pen, doing my best to stick to the letters and numeral shapes. As you progress, you will see these more and More the 'S's, 'V's, and 'C's etc.

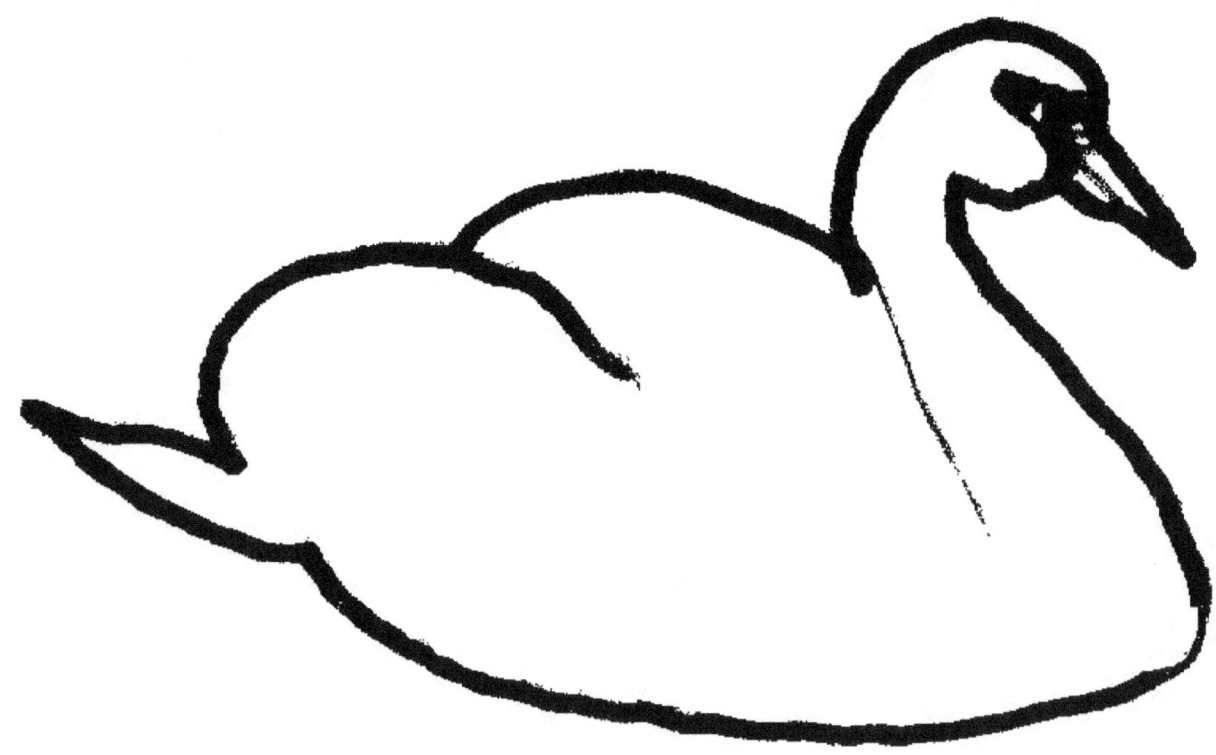

Wow! Look at this. Talk about an easy to draw! You do not need any clues, as I am sure by
Now you know what to look for, but just in case….. 'U' and 'V's Ears, nose, big 'C' circle body,
Even 'V's for eye shape

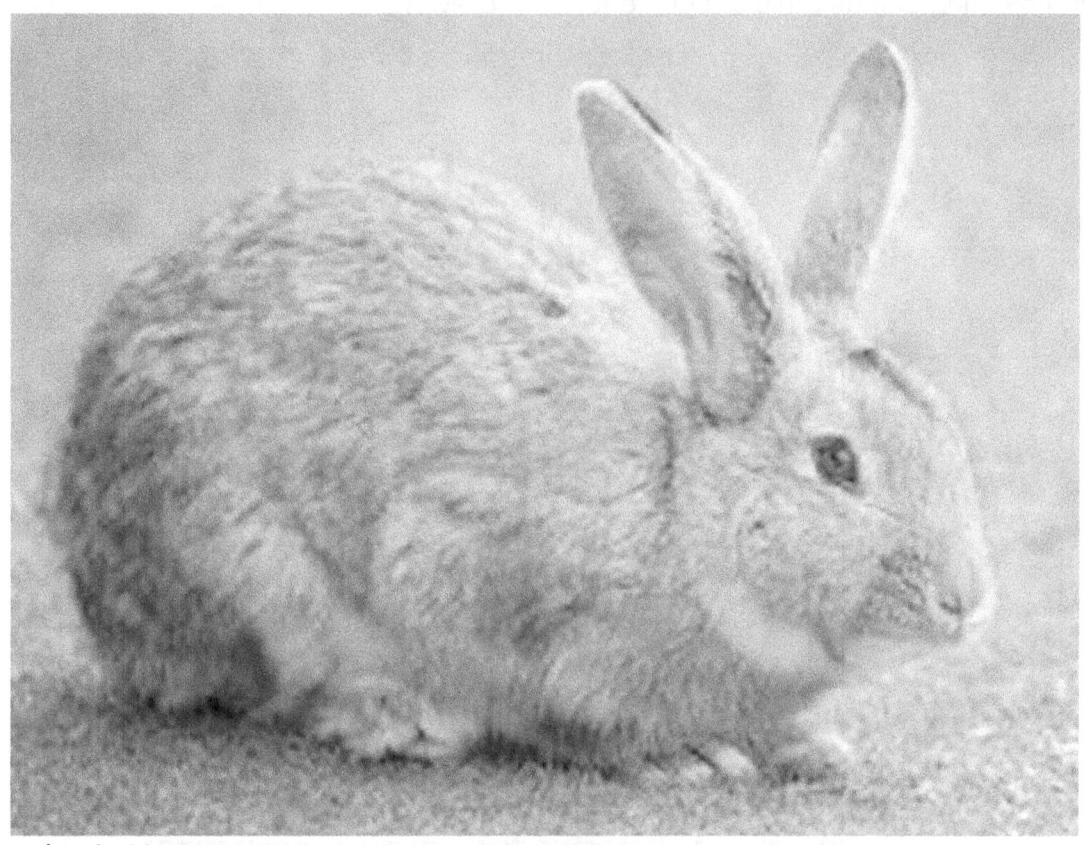

Here is my simple black marker pen drawing of the rabbit.

Upside down
V Shape Ears

V Shapes

Circular Body Shape

Plenty more
Keep looking
And Drawing

Diamond Eye

V Shape
Nose

A super looking little puppy dog. Now take a good look at him first, before you draw. Can you spot Some 'V's Upside 'V's, 'U's etc.? At this stage, it is a good idea to make a copy and mark all the shapes you can find and use this a a guide for your drawing.

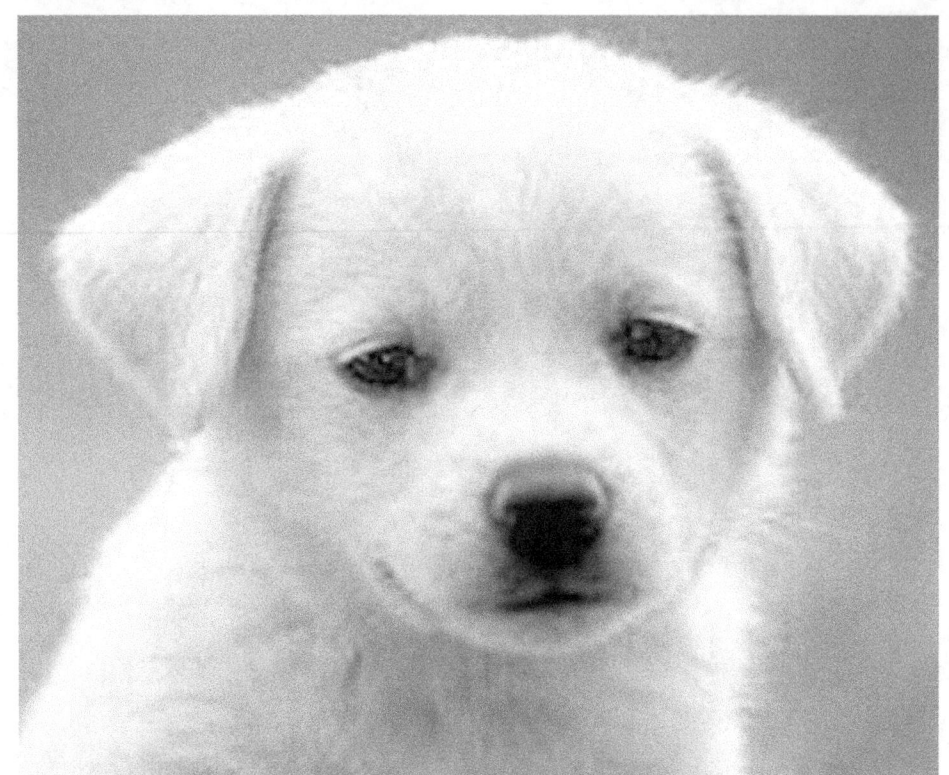

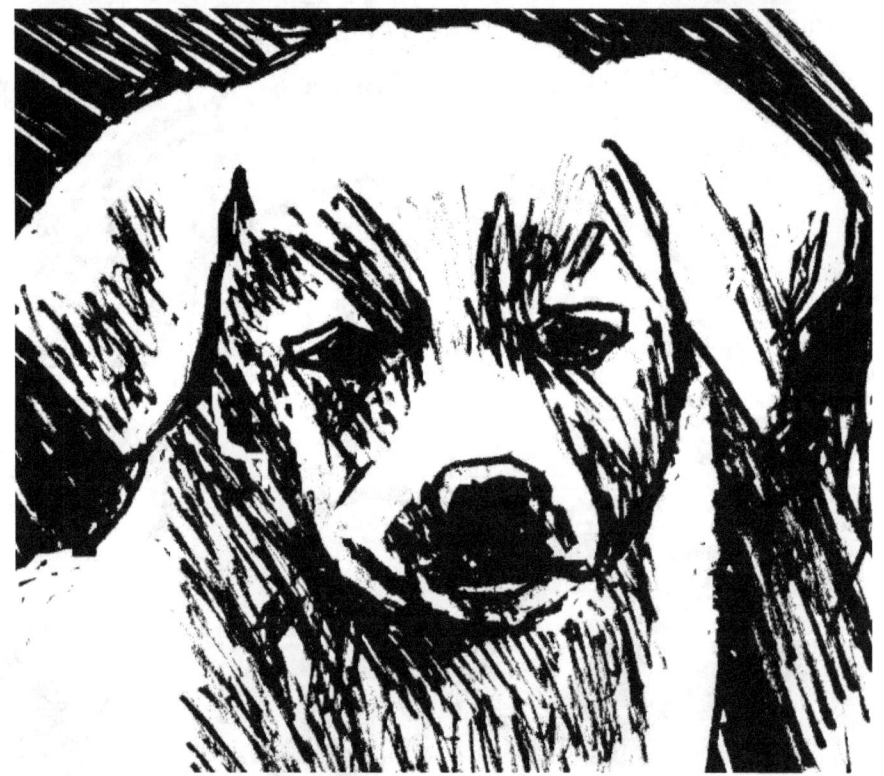

Here is my black maker pen drawing of the Dog. Sorry I got a bit carried away. Far too many heavy lines and he looks a bit sad too.

I thought I saw a pussy cat!
A great little fellow to draw and should be fairly easy for you by now. Upside down 'V's, 'U's, Circles, Squares, Triangles and '11's,. Keep looking as you draw.

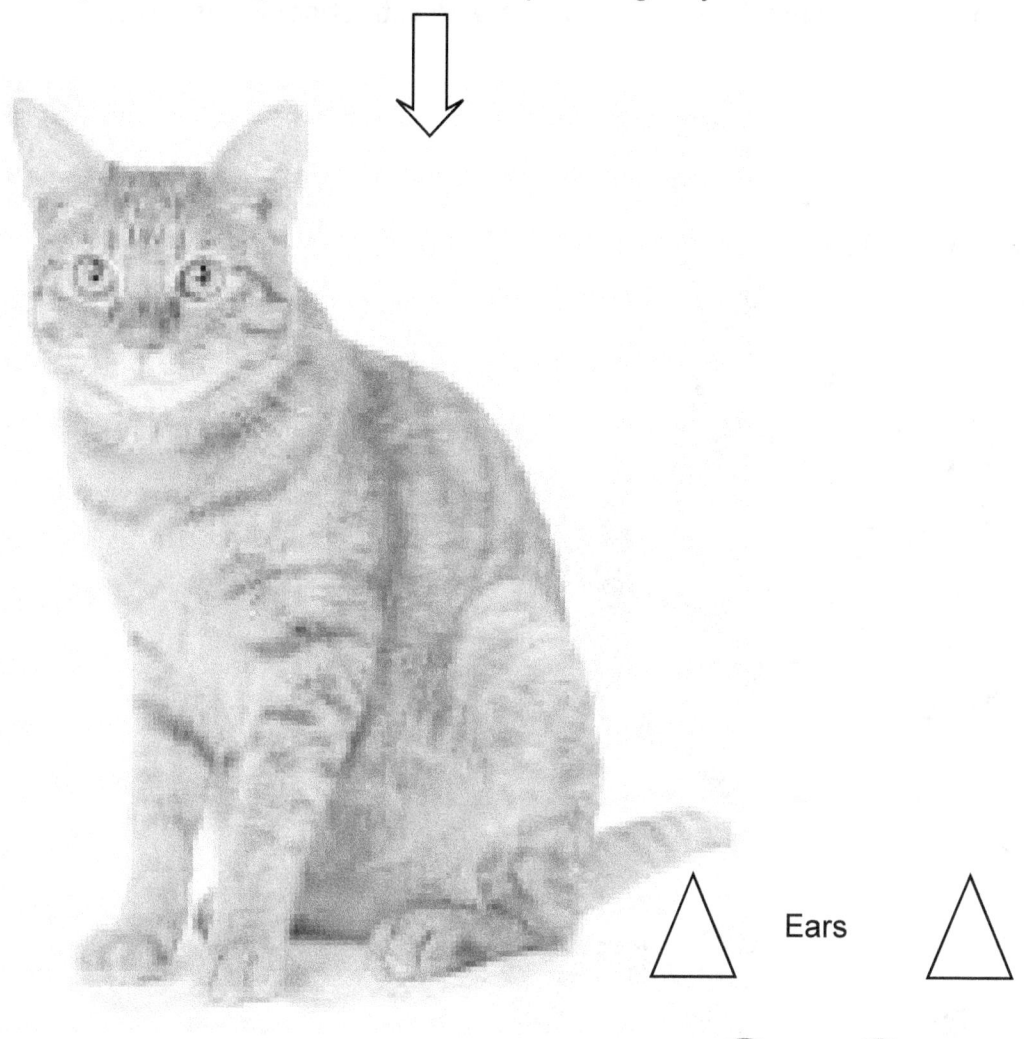

Here are the shapes and pieces to Remind you. Try to use them as they are, then refine them for a good fit. Keep looking for these shapes everywhere and you will find them.

Don't forget the Tail

Here is my rough, black marker pen drawing of the cat.
See how I have tried to keep to all the basic shapes, together with some scribble.
Please use a pencil and and maybe refine your drawing with shading afterwards.

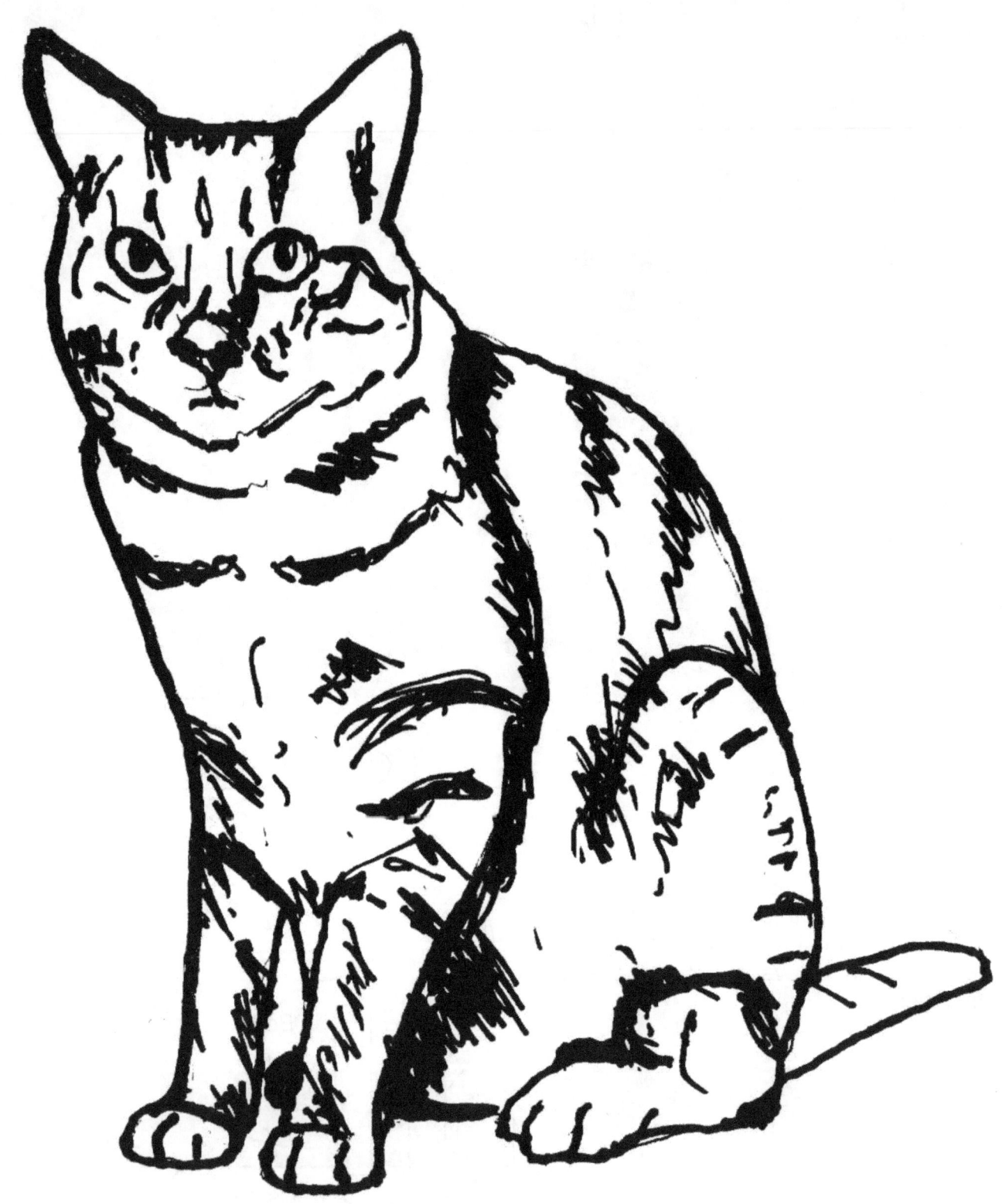

Hi.
Could not find a decent picture of a dinosaur, but I have drawn this one with my usual marker pen for you to see and copy. I also had him sticking his tongue out, but you do not have to do that.

Notice all the 'V's on his back, which are great fun to do. Almost a circle or 'O' for his tummy, 'U' For his neck etc. As usual, when you have made a copy, please do one of your own.

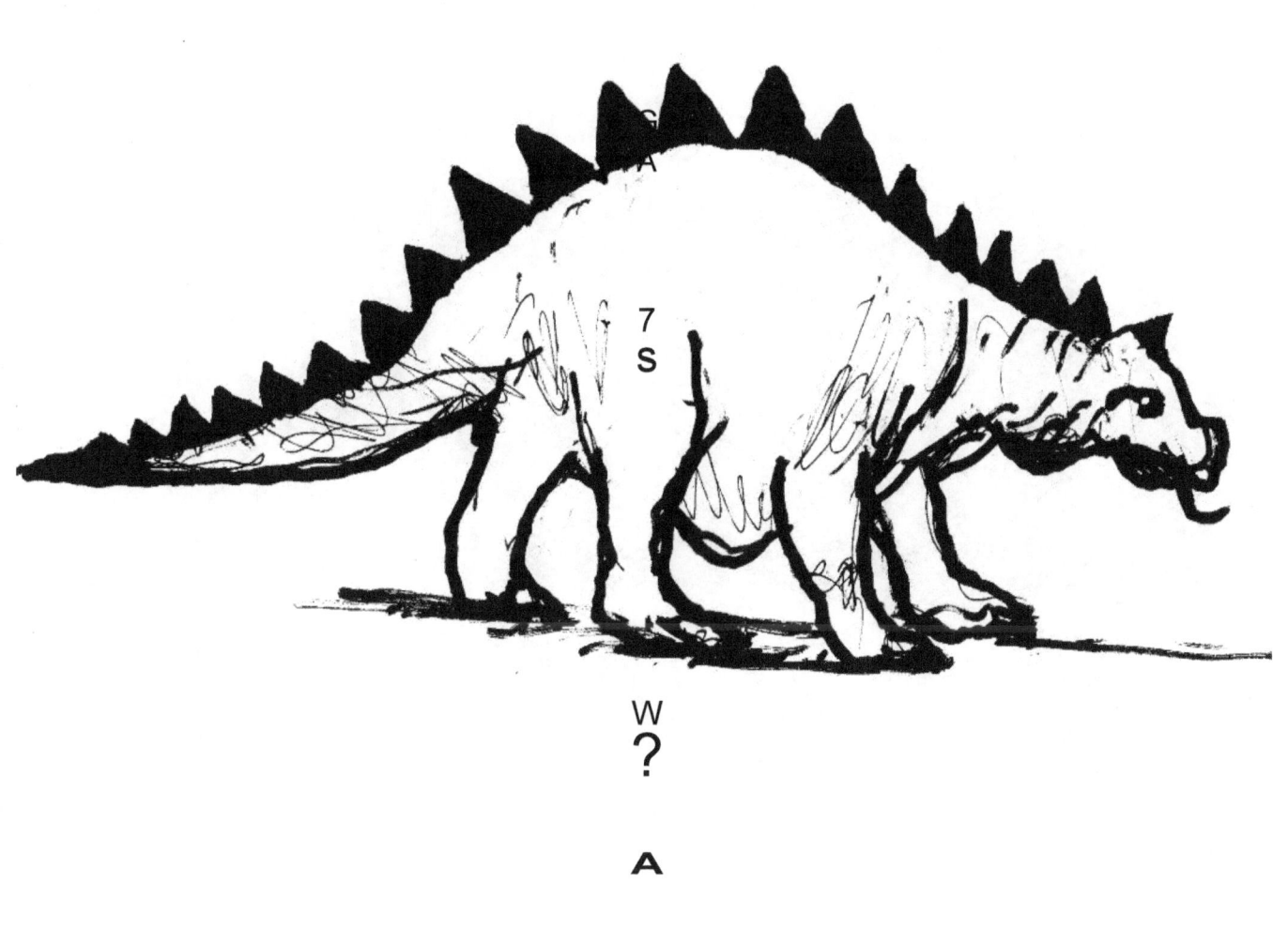

Our last Animal pictures are of a Elephant and a Pig. I love these.

They are very popular so do your best to copy mine and then make up your own.

Do not forget, it is what you make up yourself, using the letters and numerals that really counts and in a short space of time, with **PRACTICE** you will not need my help at all.

Observe how many upside down 'U's scream at you in this picture. The main bulk at the rear is almost an 'O'. Look at the 'U's and 'V's around his ears, Triangular feet? Keep looking and write every shape, numeral and letter down before you start drawing and when you draw, you will still see more!

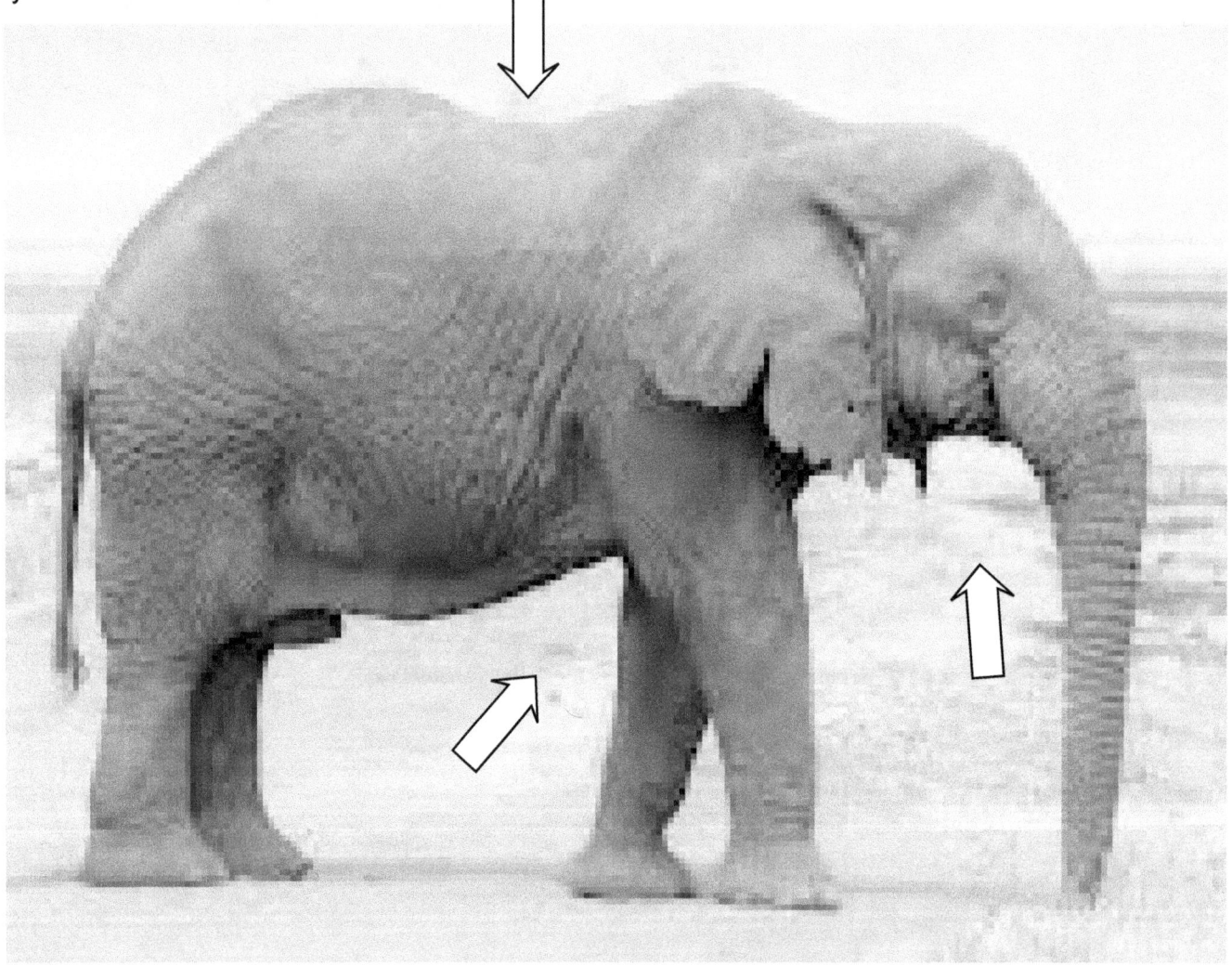

By the way, it is a good idea, to take a copy of any picture you are going to draw, look for all the shapes, letters and numerals you can find and mark them with a black pen. This will give you a good guide to work from, also write down on a separate piece of paper, what you have found. Once you start drawing, you will probably find more.

Here is my elephant .
Please note, all my examples, are very rough and made with a black marker pen for clarity to show how, with simple shapes, you can create whatever you wish to draw and I am doing my best to keep the basic shapes of the, letters and numerals, yet still make it look like the subject, This is not an example or the quality of work I normally produce. Please turn to the rear of this book to see examples of finished work.

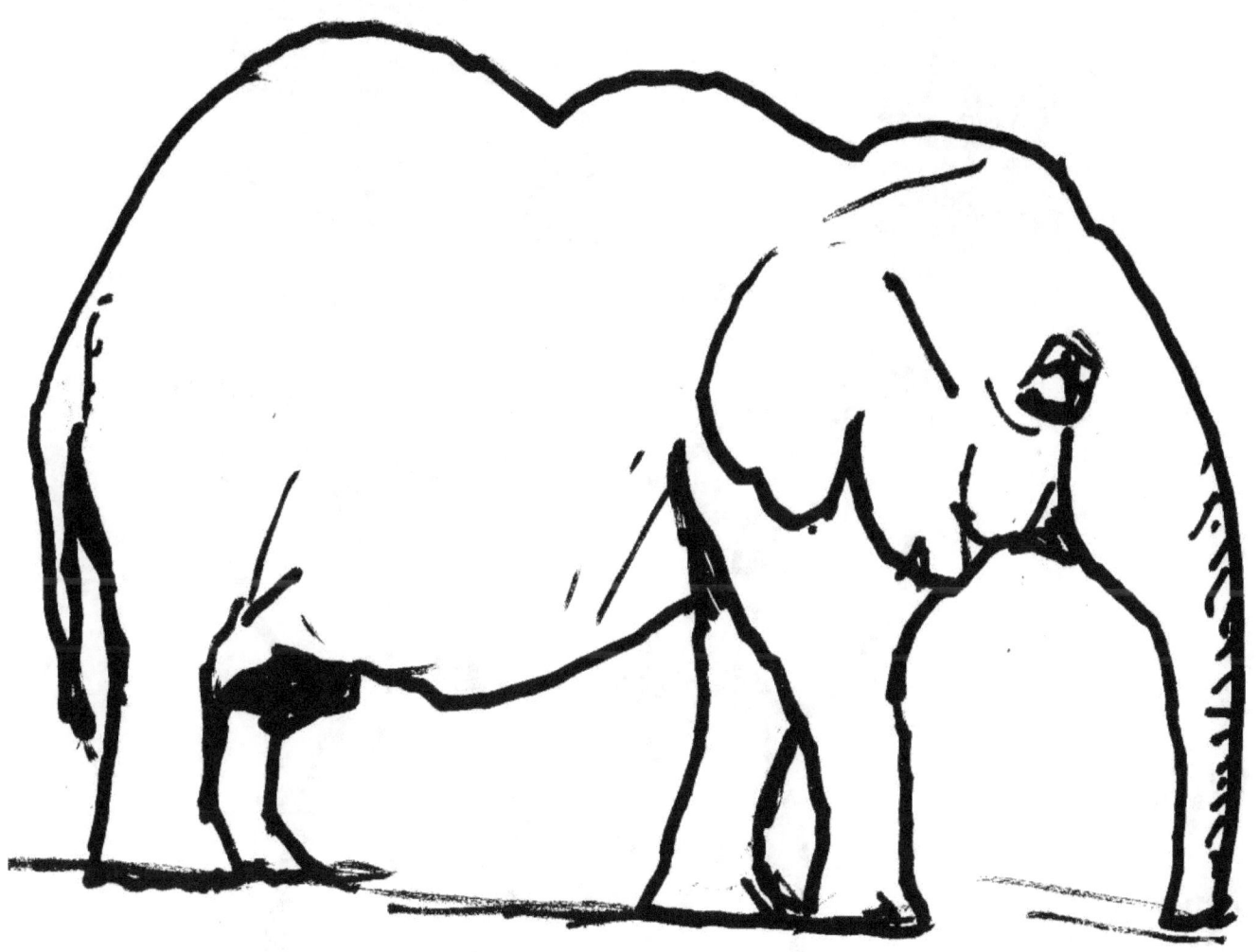

He is singing 'I Believe I Can Fly'

(He will never make it. This guy is overweight)

Ah! I love all Pigs.. (Not some of the human kind though).

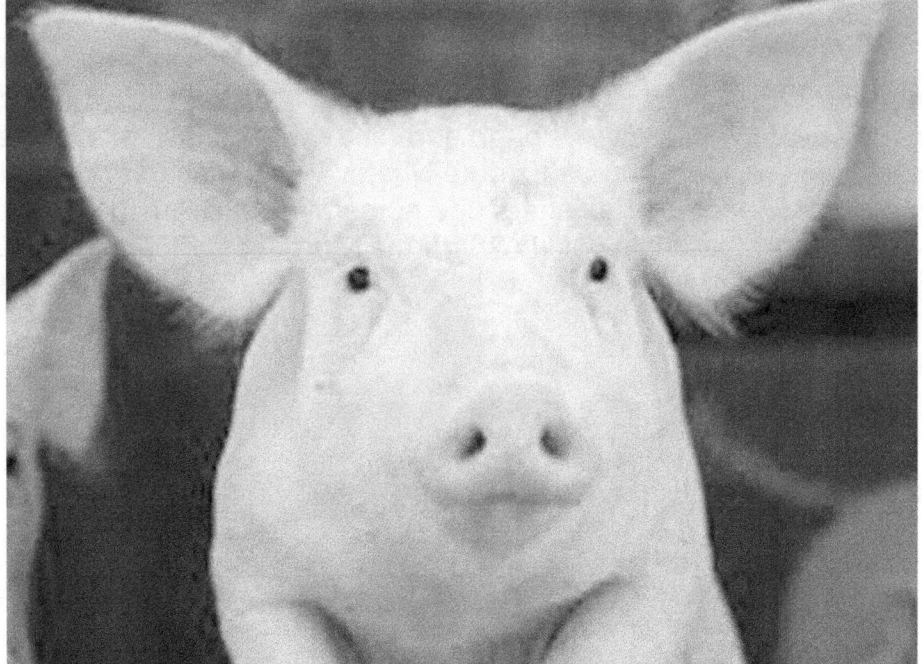

'V' Ears

What's for tea Ma?

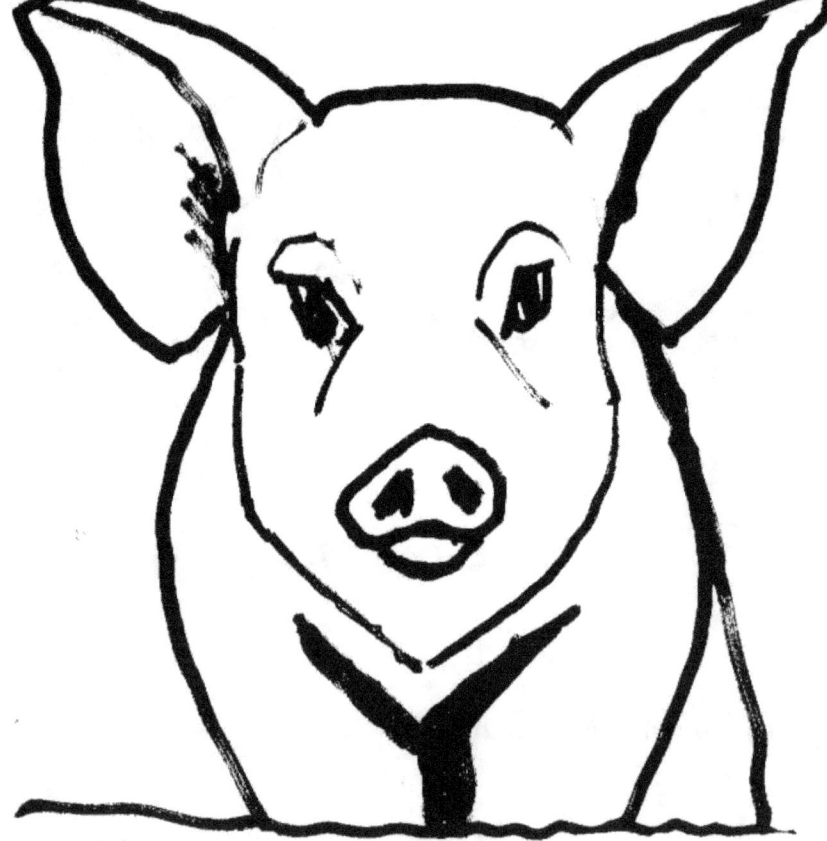

I had fun drawing him. I do hope you will too
'C's 'D's, 'V's, diamond shape eyes and look at his upside down heart shape nose
.

Okay. Our next projects are buildings, which we can see everywhere.
All you have to do is to look and break them down into shapes you already know and can draw.
We all know our Squares, Rectangles, Boxes and Triangles because we have been hard at it
practising drawing them all haven't we? Now reap your rewards from all that hard work
Like playing with toy bricks, you can build (draw) your buildings, even make up your own designs
Below you will see examples of buildings for you to copy, then draw a few of your own..

Look at the famous Bullet shape building we have in London
Simple! Everyone knows how to draw a bullet.

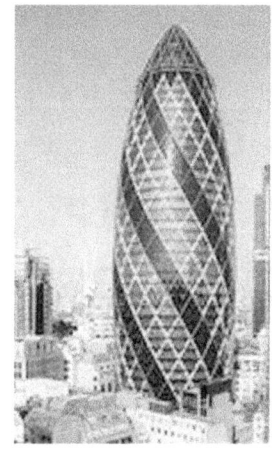

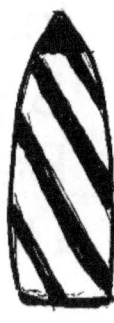

These buildings here, on the right, are really only simple boxes and rectangles. Practice a few, separately a first, then complete the picture and remember, it does not have to be an exact copy.

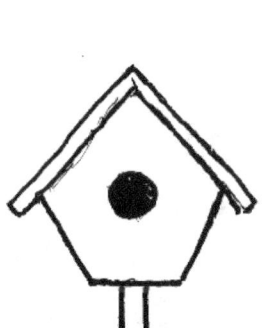

Drawing a simple house, is actually more difficult, but not for you.
Try something like this one here. Okay, a joke, it is a bird house.
Still good practice though.

 ## Cuckcoo!

Pretend you are playing with toy bricks and have fun drawing these

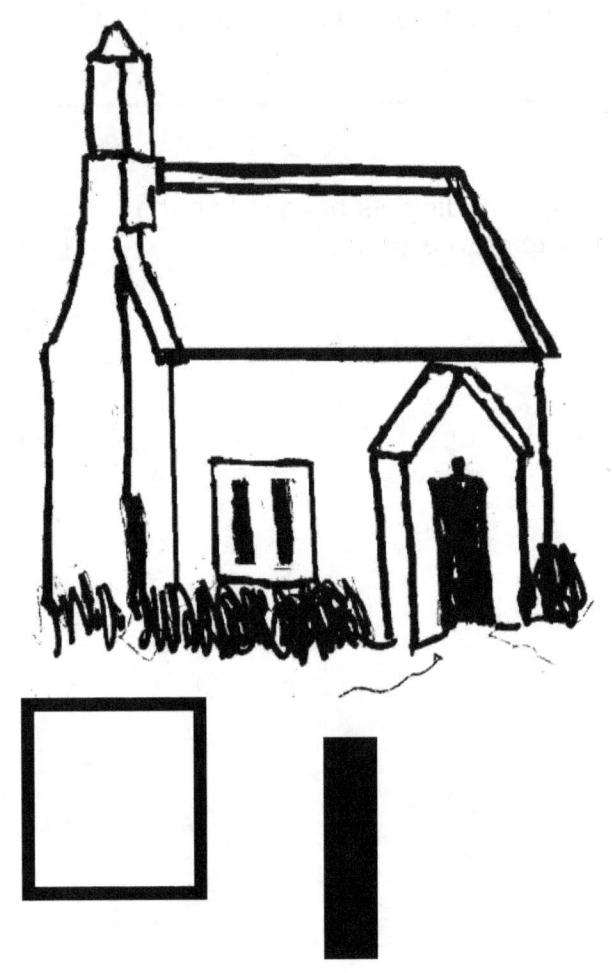

Always remember,
look for and use, your
Squares - Rectangles
Boxes - 'V's
Upside down 'U's etc.

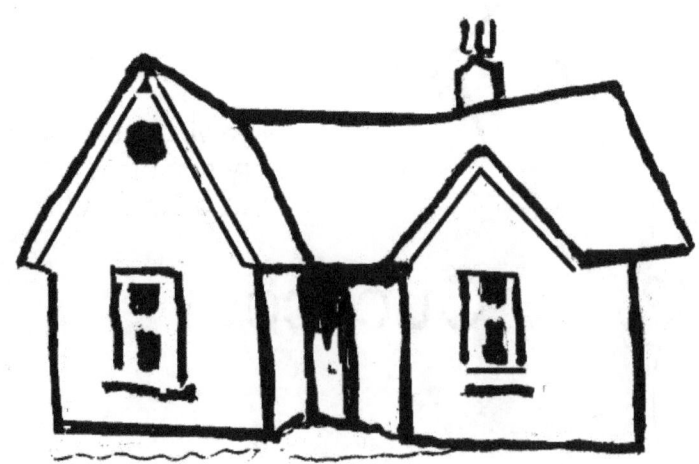

Study this picture before you draw

This is a picture I took of an old derelict building in Canterbury. It was a large art shop and store. I used to go there for supplies when in the area. Perspective comes into play here, but you can make it look right with a little bit of effort. First of all, note and mark the area (outside shape). Then look for the horizontal and vertical lines i.e. the roof and bottom of the house also the building on left and right. The windows and doors too, will all be vertical
Notice our friends the triangles and square shapes. The tricky bit is the angle of perspective, but if you have your horizontal, vertical and triangles correct, the detail of the windows and doors should not be needed. Hold your pencil in line with the angles and close one eye, this should make it easier! (Don't close two eyes it's harder)

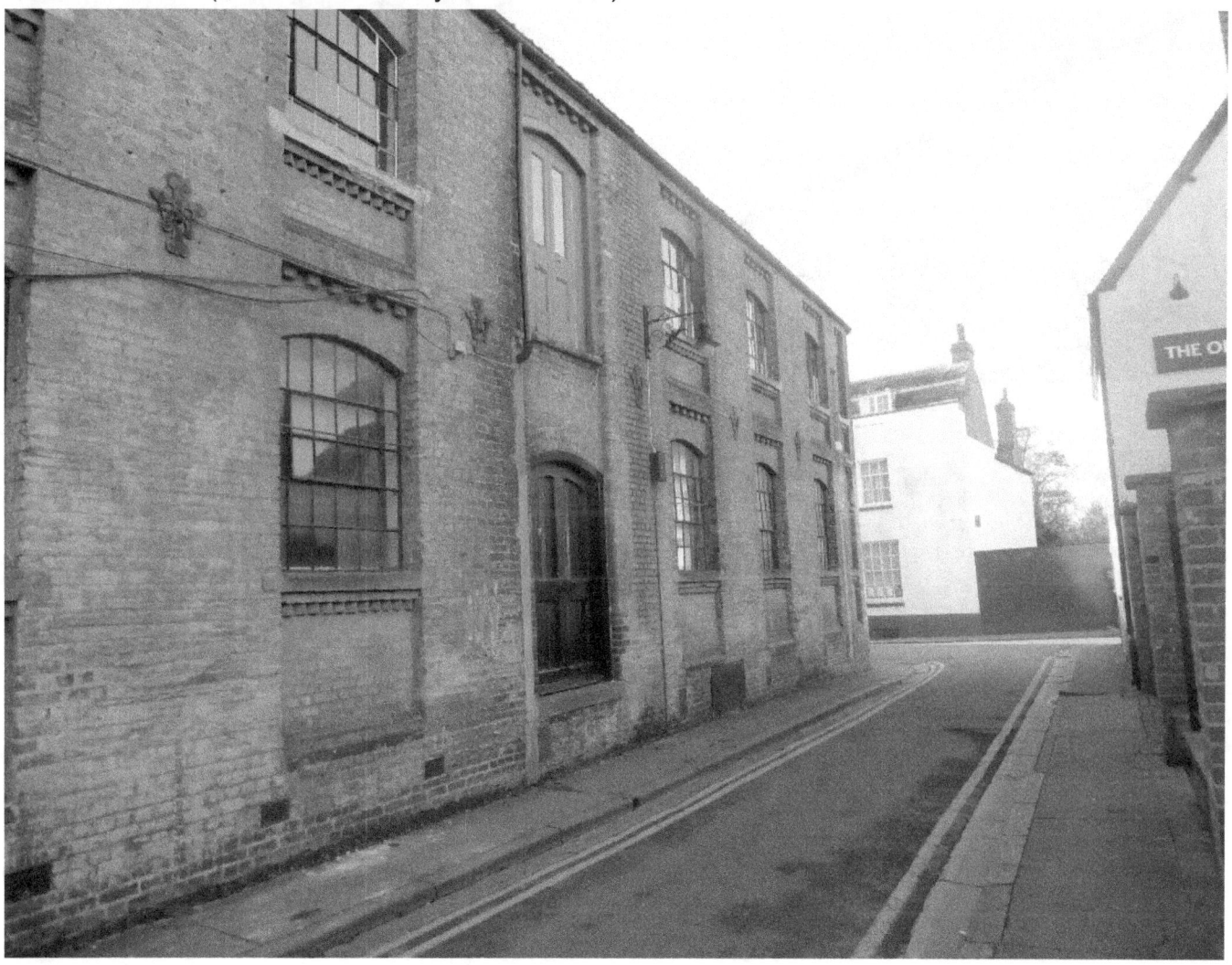

Here is my quick sketch with marker pen and I am sure you can see with refinement, how this could easily be turned into a decent drawing or painting. Think of how you could add Clouds, Birds flying, Shadows, Brickwork and of course colour. Maybe people too, which we will cover in a later lesson.

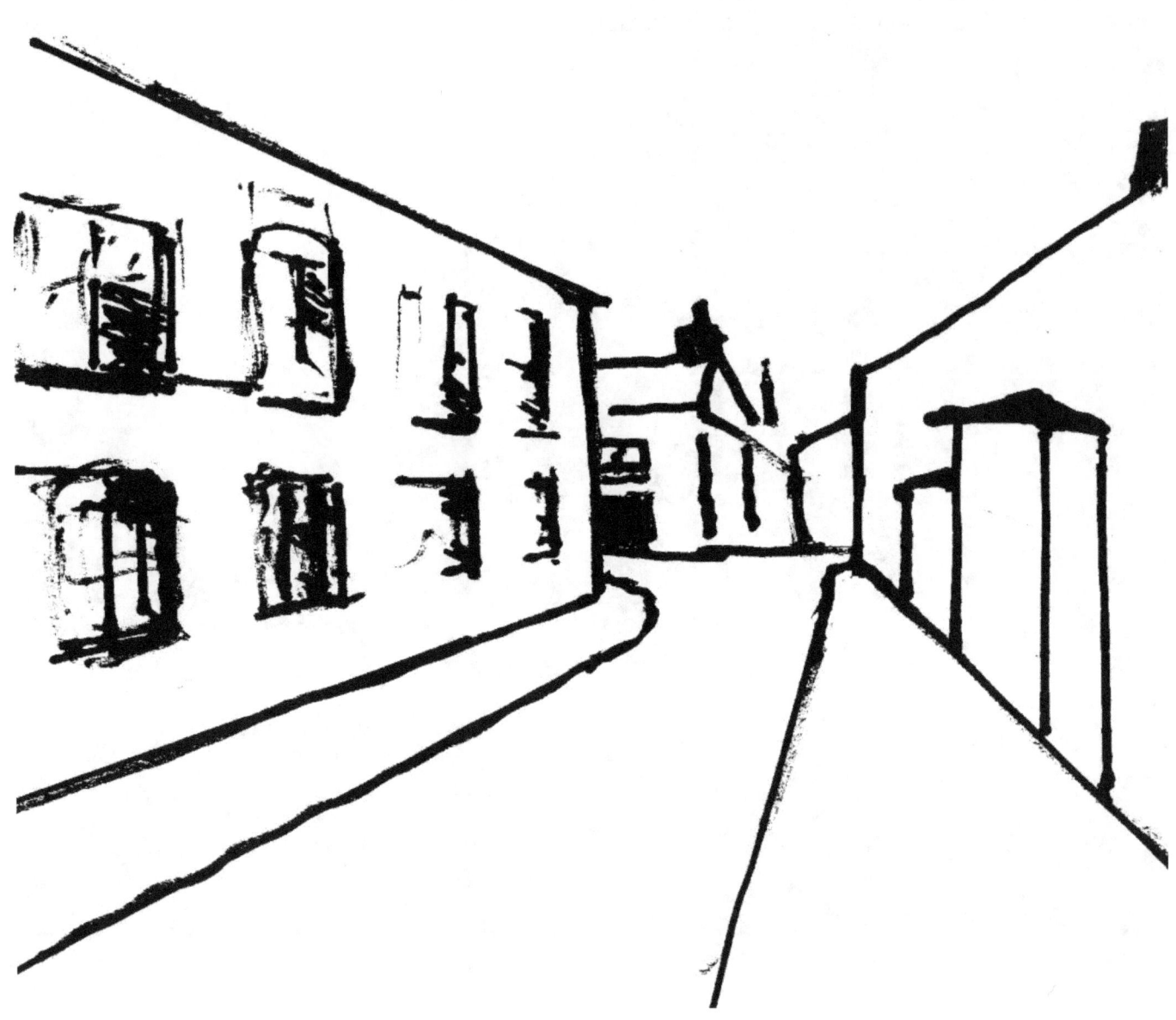

Trees are easy to draw, as long as you go about it the right way. The rule you all know is, always start with the outside shape and this is never more true than when you draw a tree. Look at the one below. Can you see the upside down 'U' shape? Or a giant 'C' on its side. Draw this first, hen put In a number 11 for the trunk. Once you have completed this, you are well over half way done. Later on I will show you how to refine your drawing.

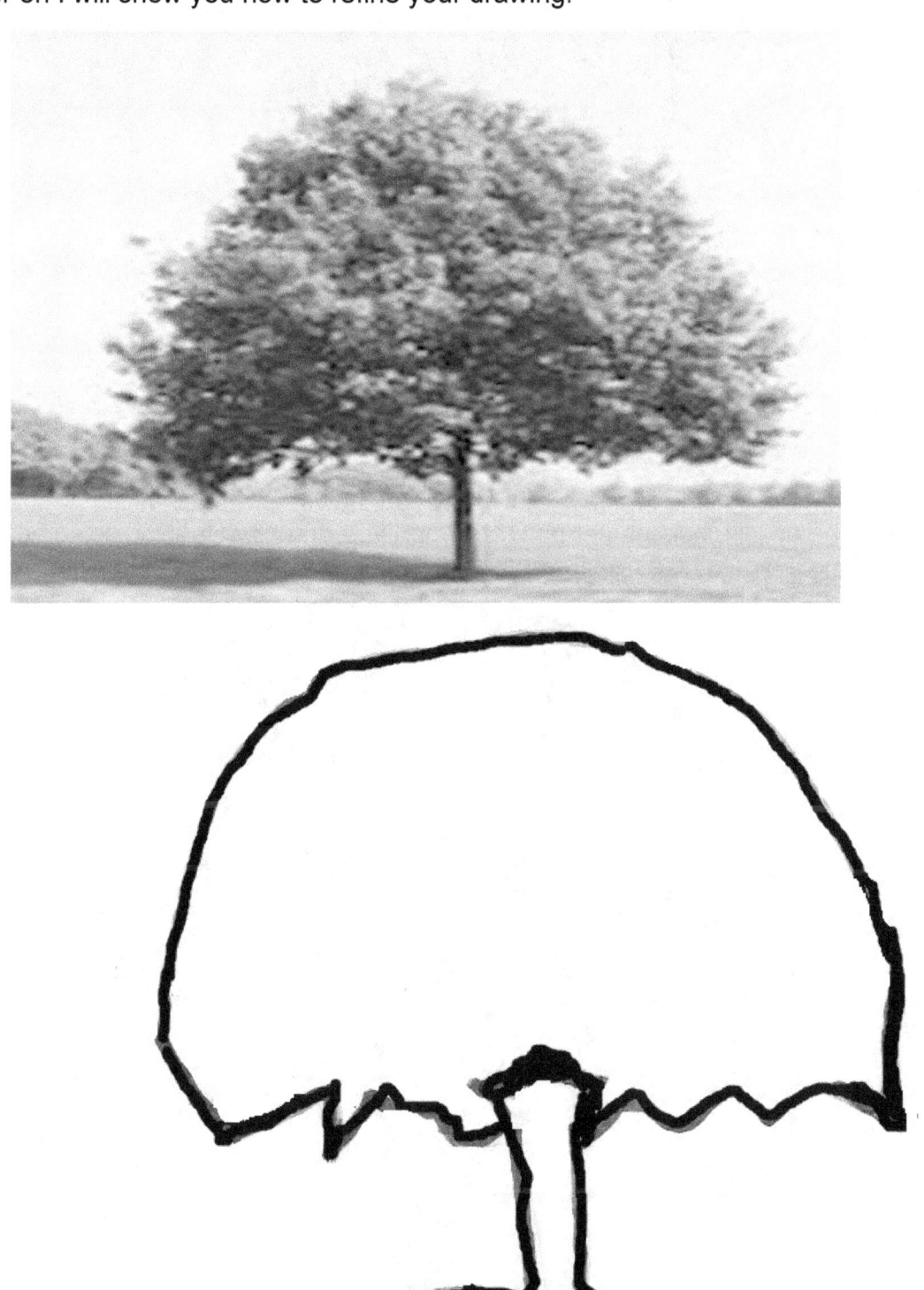

This is my tree, in a very simplified form, so you may see exactly how to do it. Make sure you have a nice shape. As humans, we naturally observe the whole view of a tree at once and this Is why the outside shape is so important, nevertheless, you can see the upside down 'U', 'V's No. 11 for the trunk etc. Now try one of your own before moving on.

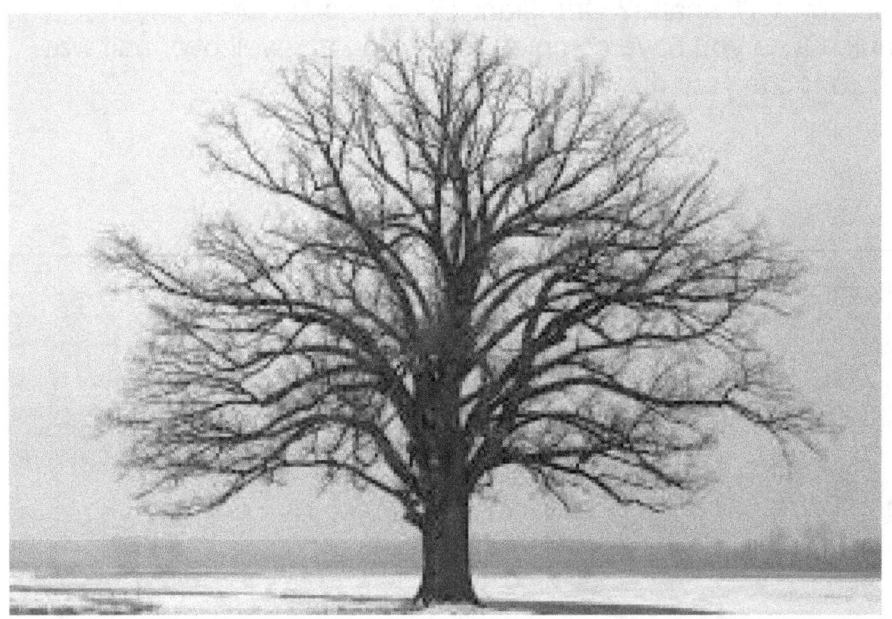

This next tree in winter, but the same rule applies for the outside shape.

I have purposely left the outside shape line to show you, how important it is.
My drawing is in the usual black marker pen, but when you draw, use pencil, so you can erase the outside line, making it more like a tree in winter..

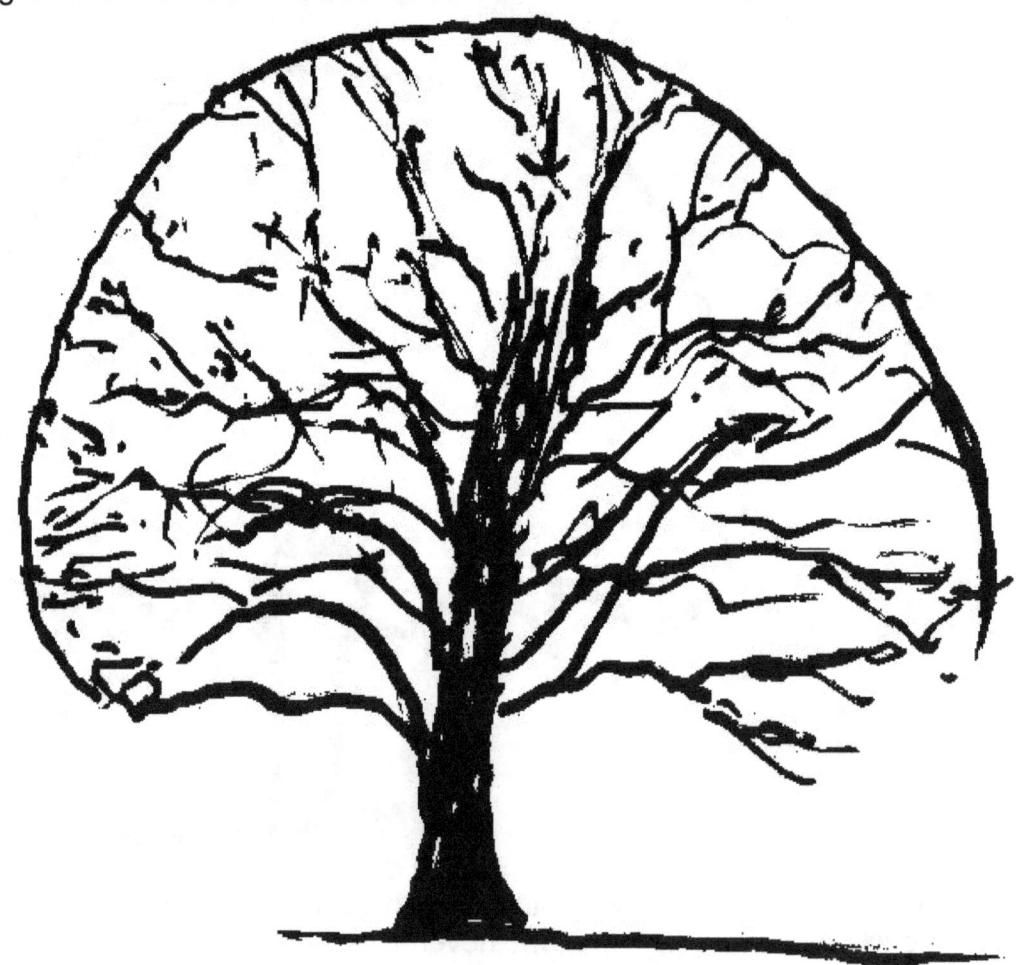

Here is a quick landscape sketch, so simple yet effective.
Nothing more than upside down 'V's '11's, 'U's and a few simple strokes ('1's)
You could draw and colour something like this and transform it into a lovely painting.

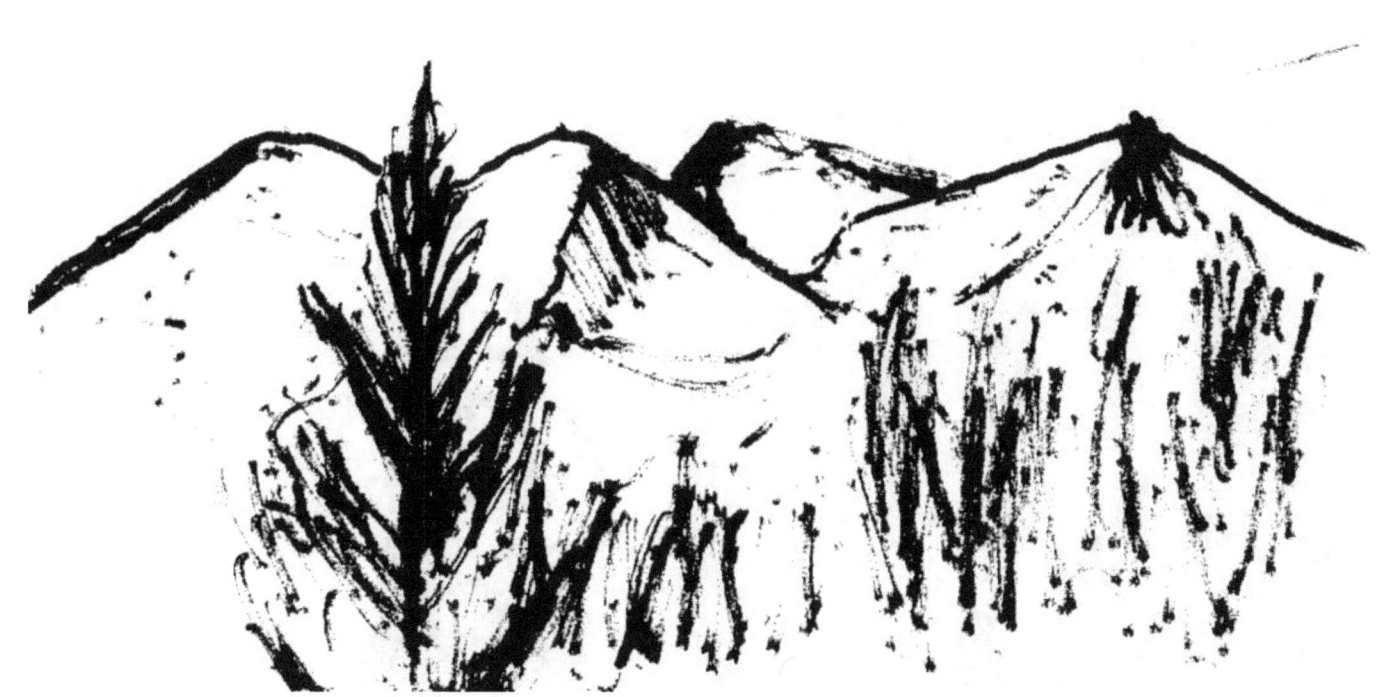

A lighthouse.
not such a clear picture, but no matter, we can always draw what we see as best we can.

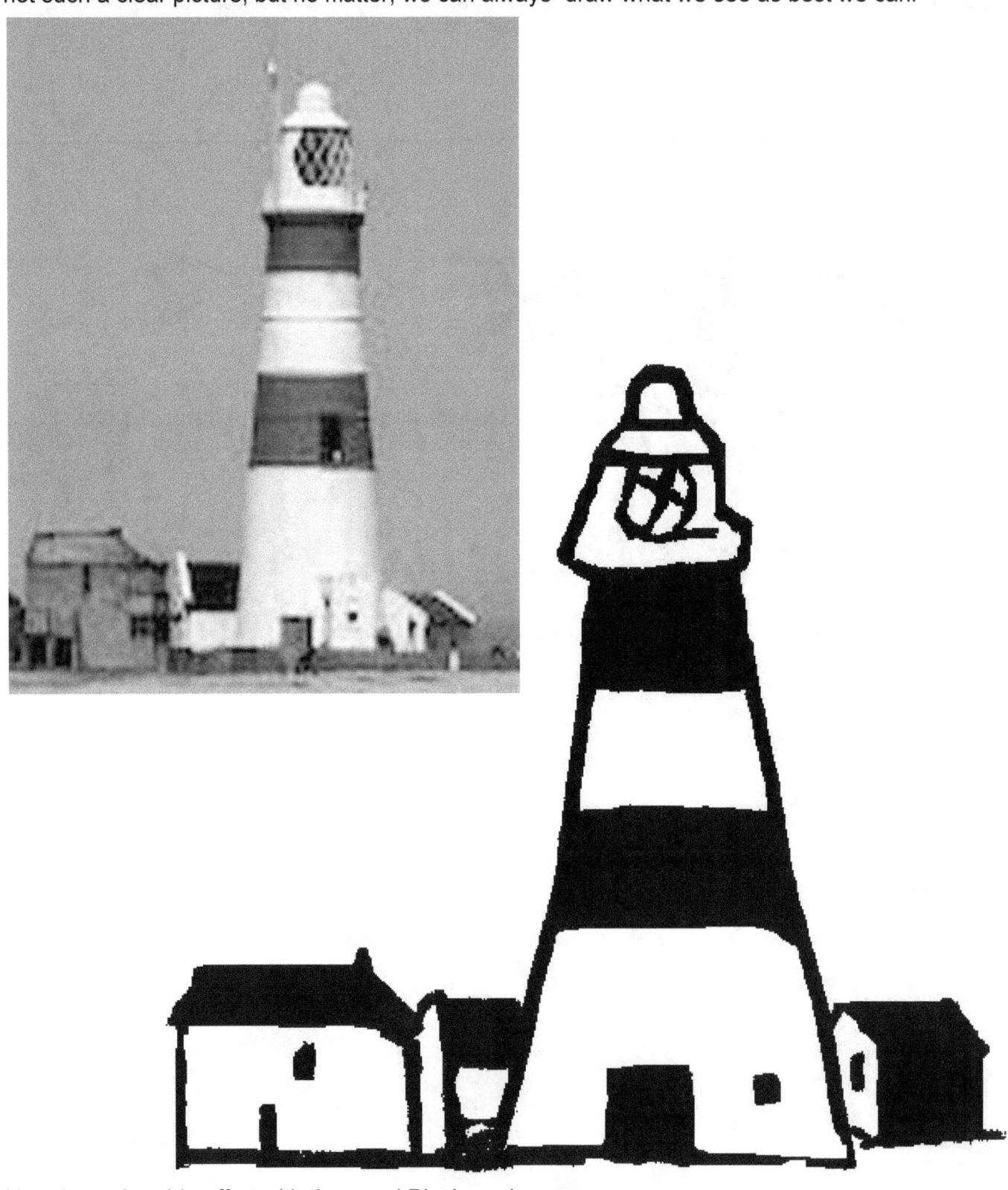

Here is my humble effort with the usual Black marker pen.
Please do not try this at home. Use a pencil.

Flowers! Yes, everyone likes flowers, but they could be in a Vase or growing wild in a field or in a Wood with lots of trees.. In fields we have landscapes with maybe Sheep or Cows.. Now is the time to make your own examples as I am only going to show you a few simple flowers.

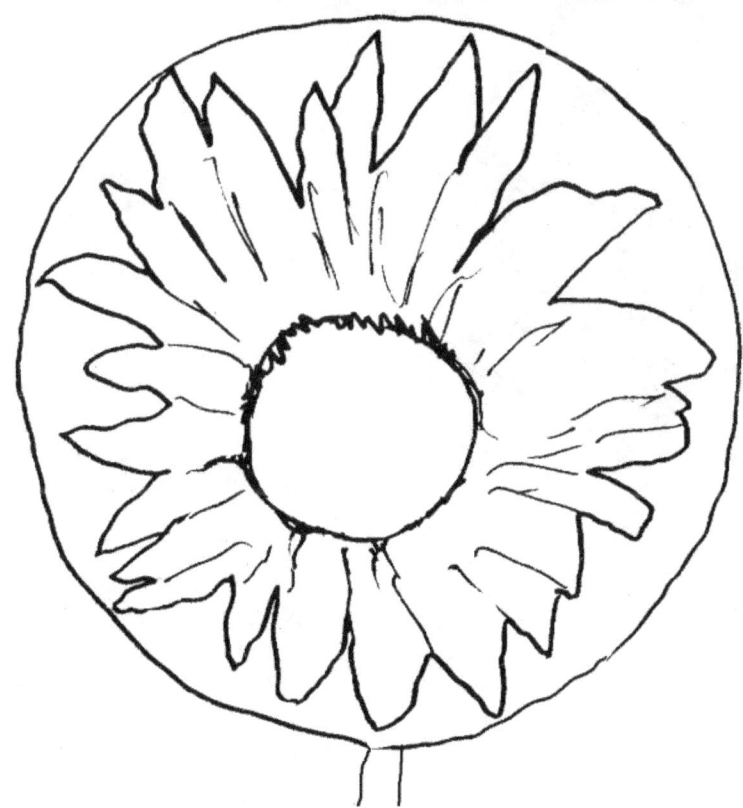

Here are a few other flowers for you to draw. You probably have them in your garden or in vases or pots around the house, so now is the time to draw some LIVE!!!!!! You know the technique of starting with the outside shape. Here are a few simple examples below. Most are easy, but a few not so. Any you have a problem with, you will overcome if you **practice first!** No artist gets it right first time, every time. A great British artist, drew a local scene, about seventy times, before he was happy with it. The clues of what to look for are dotted around to help you.

1/. Seek and find first
2/. Draw
3/. Then refine

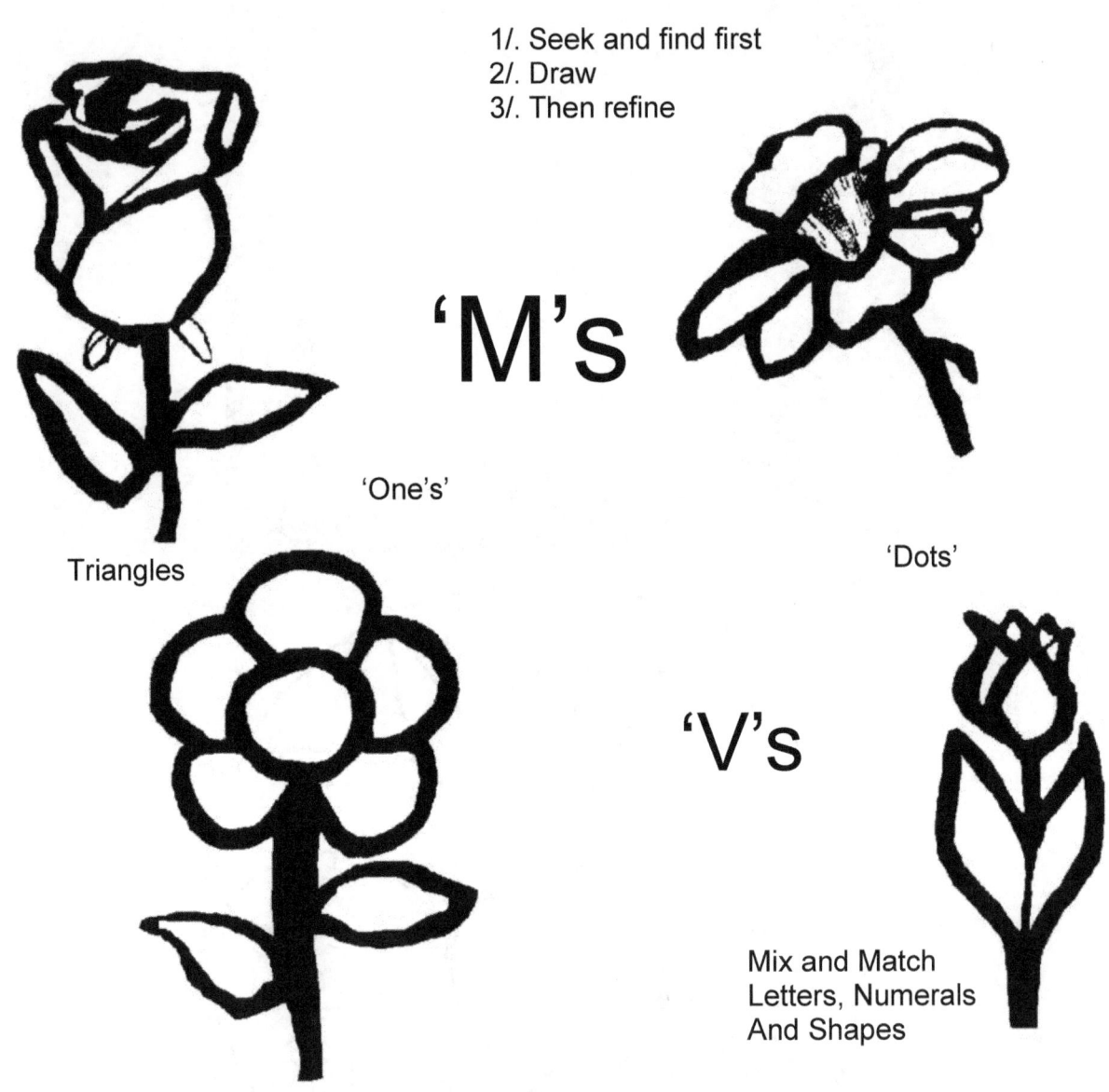

'M's

'One's'

Triangles

'Dots'

'V's

Mix and Match
Letters, Numerals
And Shapes

Lots more,. Keep looking

Time to remind you to keep **LOOKING** and **PRACTICING**. Do not just read or draw what is here in the book, do tons more! The more you do, the better you will become and that is a promise.

Today, go back to your first project of Funny Faces, make up your own, using different eyes, noses and positions of the head. Do the same for all the projects you have covered so far.
A great benefit of doing this, is you can see the improvement you have made, not only in your drawing, but your imagination too! You will find this a huge boost for your confidence.

Homework Lesson

Yes, even the wonderful entertaining world of drawing, does require you to do homework. With me and many others, my art is a 24/7 full time process. (I dream about it too)

You dear reader, on the other hand may only use your art as a relaxing hobby and that is great, however, I must use that ever repeating word of practice comes into play and the old saying of "Use it or lose it" has never been so true as applied to art and drawing in particular.

The heading on this page is lesson and it is a very important one. What you have to do, is draw a landscape, but make sure you use all the letters and numerals. Yes, every single one of them including dots and dashes. Fill out the entire page, then check you definitely have them all on this one sheet of paper. Double check you have by looking at your computer keyboard or typewriter and as a matter of fact, it is a good idea, if you have a copy of a keyboard, pin it up on your wall as a reminder. Have fun searching for all of them..

The next and last lesson here, is on observation. I would like you to choose a well known drawing or painting, (one you really like is best), then do some detective work on it by looking and finding all the shapes, letters and numerals the artist has used in the picture.

For an example, nearly everybody knows 'Girl With Pearl Earring' by Vameer, a master artist. I would like you to do your best to copy this lovely picture, but before you do, look and discover all the wonderful shapes he has made in this painting. Make a photocopy and mark all the shapes, letters and numerals you can find. There are masses of them and this is a great exercise for observation.

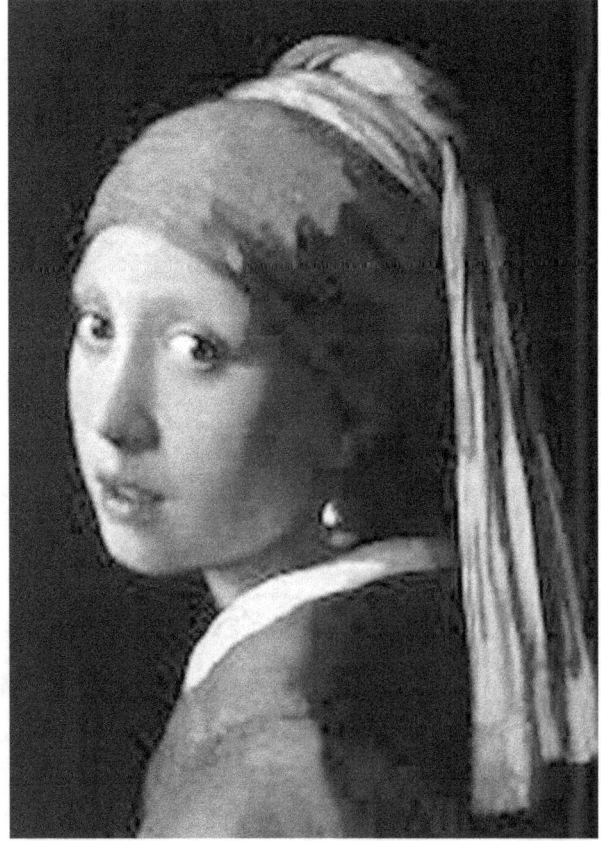

Here is my version and findings, but there are many more.

At the time of writing, I have been painting a series of post card size portraits on small 6" x 4" canvases and this is one of them. Not my best or the clearest, but good enough to show and give examples of the numerals, letters and shapes that enabled me to do this painting.

First of all, look at the top of her headdress, see the triangular shape? Moving down, the upside down 'C' covering her forehead. Now look at her right outside edge of her face, from her forehead, eyebrow, to the corner of her right eye, then, all the way down from the cheek to the chin, is almost, one, two, three straight lines. Inside the face we have her eyes (two triangles). Her nose is a perfect triangle. The lips are based on an upside down 'C' and a 'U'. The chin is a 'U'. Now take a photocopy of Vameer's original on the previous page and draw all these shapes, on the copy. This will give you a good indication of how to go about your drawing of Vameer's wonderful painting, but please pick a favourite of your own to draw.

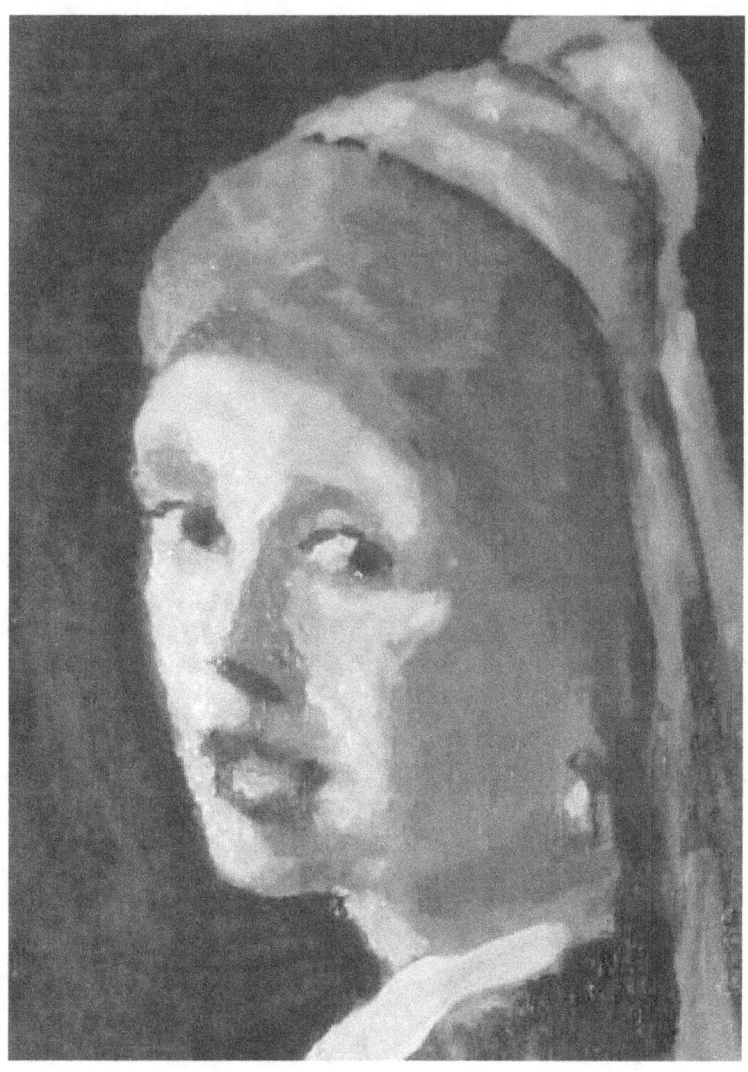

Over To You Claude

This the work of the wonderful impressionist painter Claude Monet.
Painted while he was in my home town of London. Boy! This guy certainly knew his shapes, letters and numerals, as you can see. I think he may have got stuck sometimes and overdid the '1's and 'I's, but the 'V's, Rectangles, Squares are there for sure. Now it is your turn to have a go. First of all, make a copy of this picture and mark every letter and numeral you can find and there are plenty of them. The more you find, the easier it will be for you to draw, so do some good homework here.

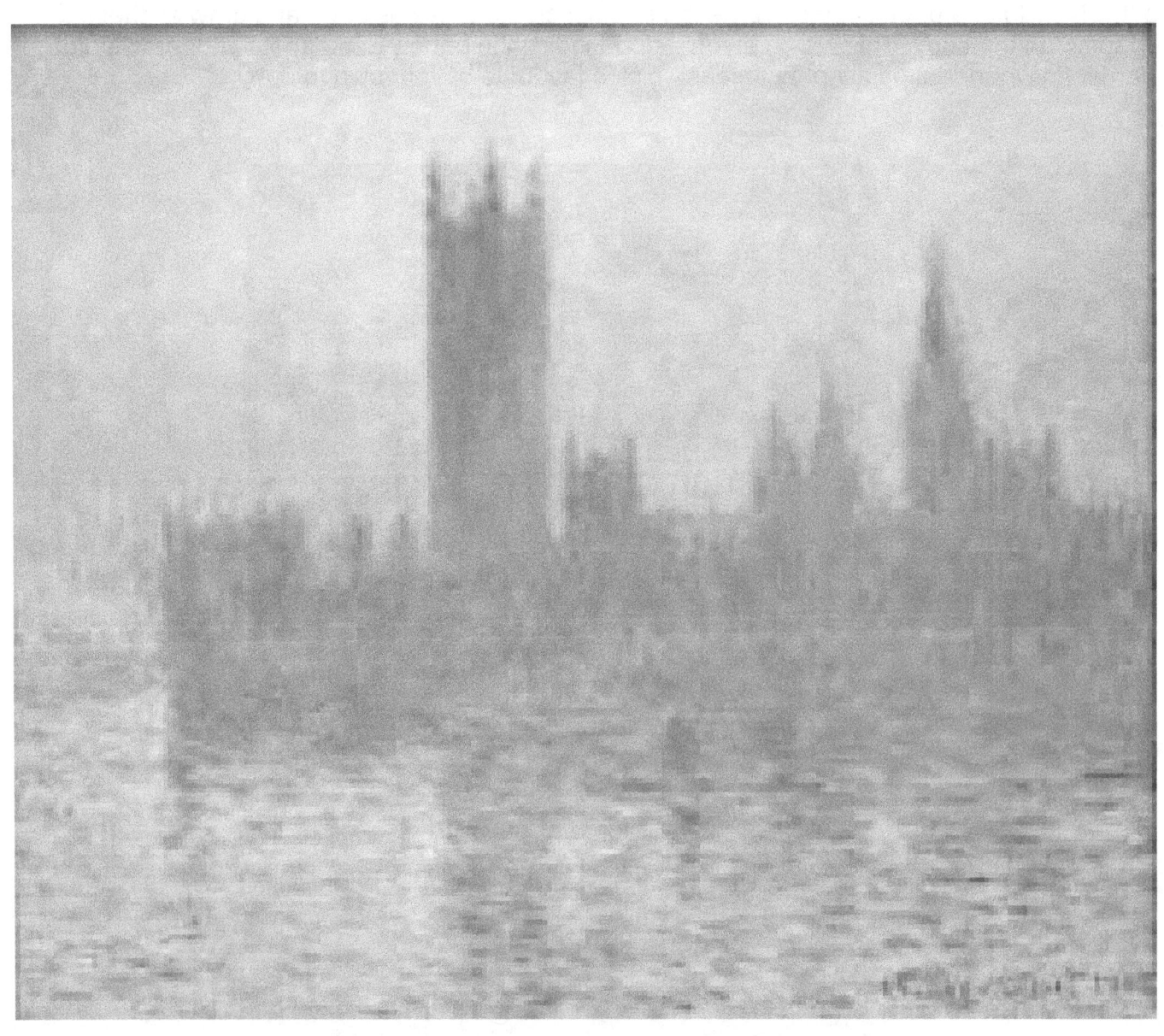

People In Your Pictures

"Oh No!". How often have I heard that, but again, it can be and is, much easier than you think. As long as you go about it the right way. First of all, forget detail. Look and study newspaper and magazines pictures that have people in the background. Notice, they are all, out of focus, yet you know and can SEE if it is a Man, Woman or Child, also, if they are walking or sitting etc.

A great example is on a rainy day with people carrying Umbrellas! Look at the pictures below. None are in focus, yet you can see wether they are walking or standing and the shapes are very easy to draw. Do not forget to squint your eyes, to see the blurry shapes. This is a chance for you to use a charcoal stick. It may be a bit messy, but you can blend it with your finger and get some great effects and it will also help you to avoid details.

When you have drawn the example below (several times), do a further exercise of picking out each individual person or shape and drawing this separately on a fresh sheet of paper. This will give you great insight into the shapes and help you to compose your own crowd scenes, without the need to copy religiously..

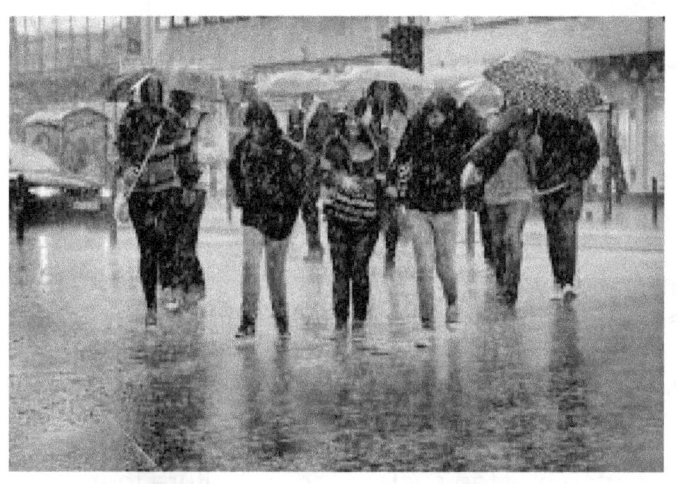
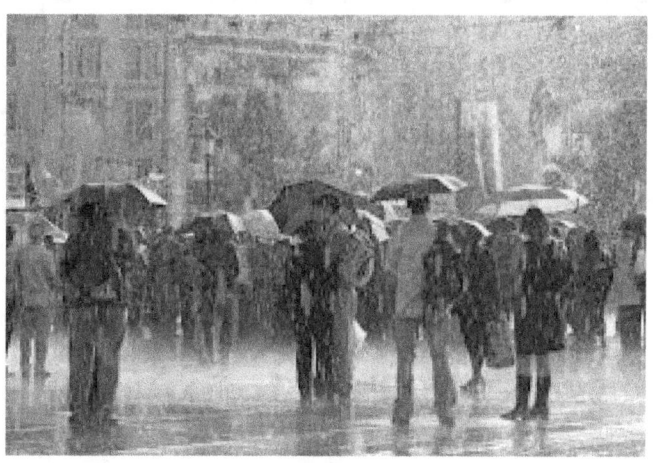
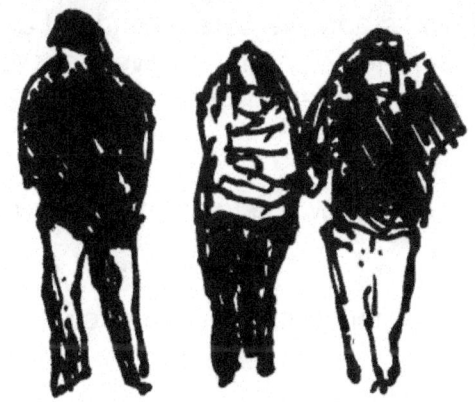

Here are a few I have done with my trusty black marker pen

Refining your Drawing

As amazing as numerals and letters are, obviously, they are limited into how much you can alter them and this is where the eye of the artist takes over. Looking and seeing a letter or numeral, that does not look or seem right for the job, is half the battle and it also means you are well on your way to winning it. Spotting mistakes and imperfections in your work are key elements for you to move forward in your art, not, I may add, spotting mistakes in other artists work, concentrate on your own. The reason I say this is I know many artists, who can spot another artists mistake or imperfection a mile away, yet never see glaring ones of their own. The best learning curve here is to observe, but not judge, this will invite negativity, which will spread like the plague.

Well dear reader, you have come almost to the end of this book, I do hope you enjoyed it and I would really appreciate your views and comments and if I can be of any help, you only have to email me. I am always willing to help. Please remember the importance of **PRACTICE,** as I have stated before, this is the only real hard part of drawing (or anything), but make it, not only a regular habit, but a pleasure.

And now a word from our sponsor

You have waded your way through the book and trust it has wetted your appetite for some serious drawing, or more detailed work. If so I would recommend my latest books for all artists
'The Clock system' and/or **'Drawing With Triangulation'** These books will enable you to draw anything and and with greater detail and accuracy, but can be used by a beginner.
'The Clock System' is similar to the famous 'Grid System', but has many advantages over it.
For instance, it requires the drawing of six lines, rather than 24, 36 or more with the grid system. Less lines equals more drawing and less erasing together with a natural learning curve.
'Drawing With Triangulation' is an age old system used by the Greeks, Romans and many master artists, but as far as I can ascertain, has never been written in a simple to understand book, this, I have endeavoured to do. It is a wonderful system and once mastered, enables the artist to draw anything in proportion larger or smaller.

For portrait lovers, my first book **'Why Measure?** (The 10 Day Portrait Drawing Crash Course), comes highly recommended (by me). This is a simple step by step system for portraiture that requires no measuring (hence the title), but I promise you, it works and is a sure way to get a likeness. I have seen and known so many wonderful artists over the years and it never ceases to amaze me, how, so many are missing the likeness of their subject, especially when their skills at drawing and painting, in all honesty, are superior to mine.

My method, or the other hand, is very natural and organic and will allow you to develop your own individual impressionistic style.

Thank you for buying this book, I do sincerely hope it will produce for you, many hours of enjoyment..

Sincerely,
Daniel McGowan

P.S.
Any questions or queries, please email me. I promise I will always do my best to help
djrmcgowan41@gmail.com

Here is a small sample of my recent works of drawings and paintings, most of which are sold. I accept commissions and ship to almost any country in the world.
Please note, all these pictures are in black and white, whereas many of the originals are in colour.

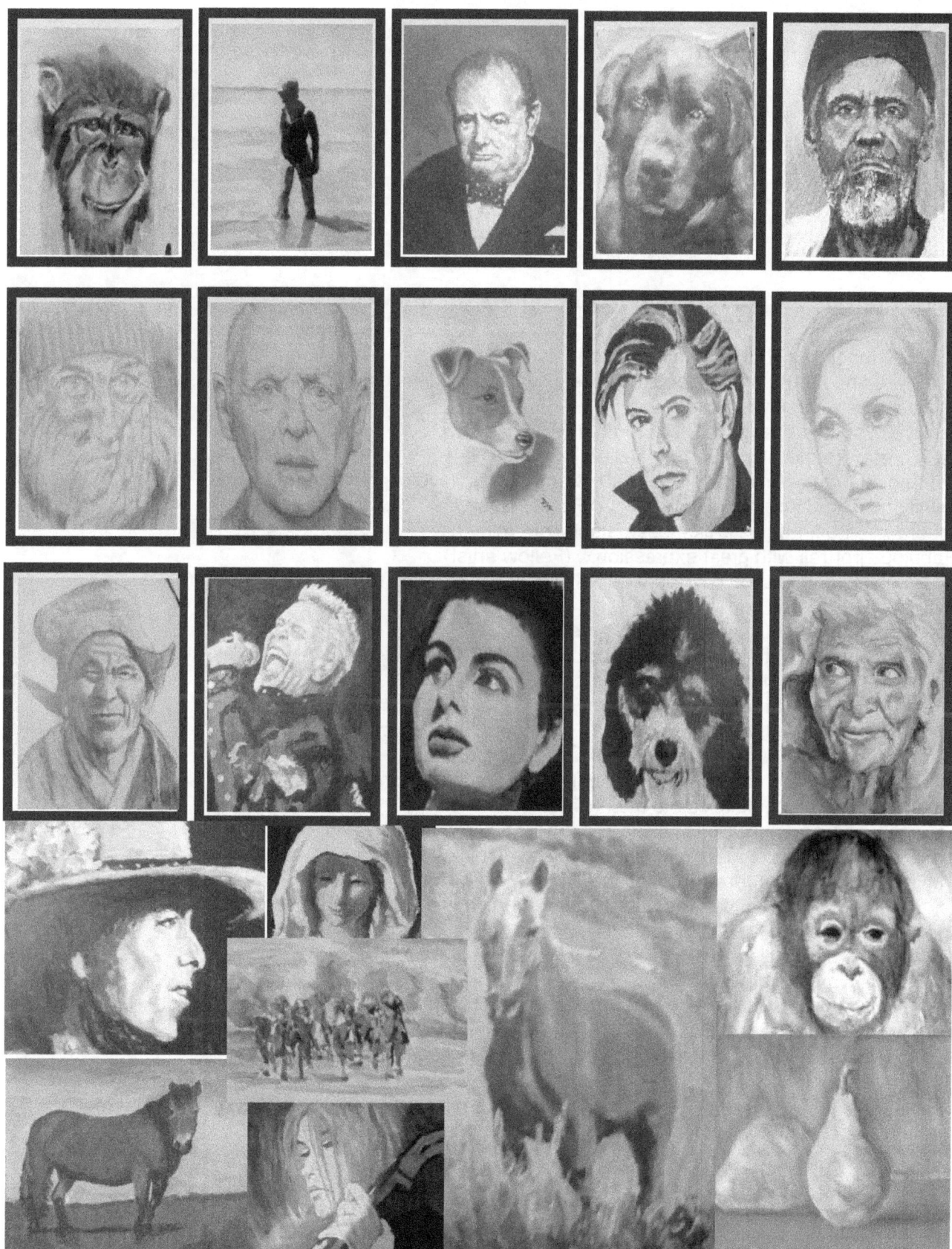

Where to get in touch if you need help or would like a portrait drawn or painted

Daniel McGowan
23, Golding Road,
Sevenoaks,
Kent TN13 3NL

djrmcgowan41@gmail.com

Pease note:-
Personal callers are welcome, by appointment only.

Some Random Comments and testimonials on my work:-

"Wonderful, Masterful strokes" (Fellow artist)
"Those eyes and mouth are so good. Definitely can see the likeness" (Client)
" Just Fabulous! Thank you" (client)
"What Eyes you have captured. Wonderful" (Fellow artist).
" This is great. No mistaking the man" (client)
"Wow! And a Double Wow!" (Fellow Artist). Many clients have expressed the same.
"Great likeness and no pre drawing Wow!" (Fellow artist).
"Wonderful portrait. Fantastic likeness. Thank you" (client)
" A Fabulous portrait with great expression.". (Fellow artist)
"This is a painting in flesh and blood. So lifelike, like she is going to speak to me" (client)
"Wow! Fantastic! Thank you" (client)
"Lovely work and great likeness" (Fellow artist)
"You really caught his cheeky face. Thank you" (client)
"This portrait is alive. Thank you" (client)
Wonderful. Thank you. I now have this as my wallpaper on my computer" (client)
"Wow! What a fabulous portrait. Those eyes are incredible" (Fellow artist).
"A portrait doesn't get better than this. Thank you." (client).
"It is like he is still in the room with me. Thank you so much. (client).
"Astonishing! Like he could speak to me.! (clicnt)
" A strikingly beautiful portrait. Fantastic shadowing". (Fellow artist)
"You are a true professional! This is a masterpiece. Thank you" (client)
"All my friends love my portrait and I do too. Thank you so much".(client)
"This goes into my book of brilliance. You capture the soul in your work" (Fellow artist)
"To get a strong feeling like this piece has - with a minimal of strokes - takes real talent.
You have it". (Fellow artist)
"Absolutely brilliant. (Fellow artist)
"I am thrilled with this portrait of our young Daughter. Thank you. When you have time,
I would like one of our eldest Daughter too" (client)
You've captured the essence of the woman in such a few strokes.....now that IS good"
(Fellow artist).
" I cried when I first saw this, he was such a lovely man. This has been a great comfort to me, much better than all of the photographs I have of him. Thank you and Bless you.(client).

Note:-:
All the above are genuine comments from fellow artists and clients

www.ingramcontent.com/pod-product-compliance
Lightning Source LLC
Chambersburg PA
CBHW080611190526
45169CB00007B/2965